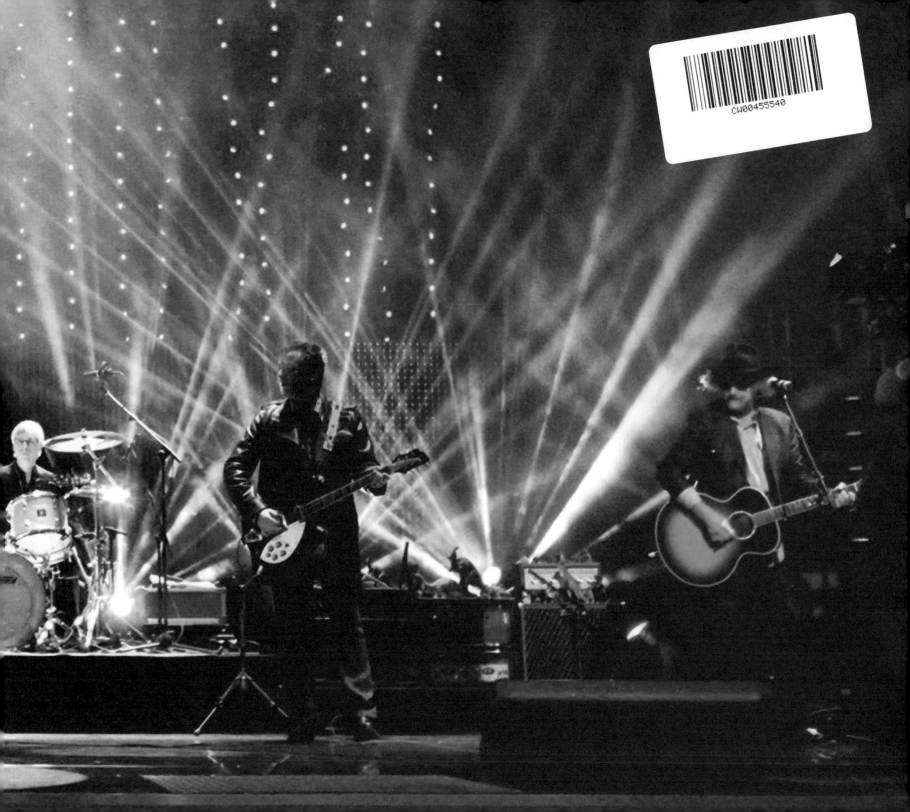

HELLO

R.E.M.

HELLO

PHOTOGRAPHS BY DAVID BELISLE

INTRODUCTION BY
MICHAEL STIPE

CHRONICLE BOOKS
SAN FRANCISCO

Library of Congress Cataloging-in-Publication Data available.

ISBN: 978-0-8118-6510-4

Manufactured in China.

Designed by Corianton Hale / Sleep Op Projects

10 9 8 7 6 5 4 3 2 1

Chronicle Books LLC

680 Second Street

San Francisco, California 94107

www.chroniclebooks.com

This book is dedicated to

the true fans of R.E.M. and to magical realism.

I FIRST MET DAVID BELISLE

IN THIS ODD, strangely-difficult-to-walk-through funhouse hotel in Seattle just after 9-11, and he turned me on to Peaches and we laughed about late-night food and bad newspaper journalists. David was introduced to us that night by his great friend Bob Whittaker; and we all of us began to work and travel together. David has a tireless energy, a quick humor, and an easy laugh and we became fast friends. R.E.M. were at the early chapters of a promotional and media tour followed by a real tour, and David asked if it was okay for him to take pictures while working. The result of that is what you see in this book.

It's hard to acknowledge and translate the actual insanity of traveling like this unless you have done it yourself. It is in equal measures the most enviable and fantastic, and the most grueling and impossible series of events—triumphs, humiliations, absurd situations and demands, and what feels like some form of permanent jetlag on speed. It's difficult to emerge unfazed. And there was David taking pictures the whole time.

Now I do and always have appreciated the arts, and the company of artists. I enjoy the attention of being a front man and public figure and subject, and I enjoy the hurtling

into the glare of present time that being on tour brings. I acknowledge and savor the time out of the spotlight as well, the quiet times, downtime, off-hours times. David manages to be there with camera and to catch all these moments without setup, his Leica click often so quiet that he might have gotten off a few shots before anyone realized the camera was even out. I don't think I ever once said put it away, not now, this is not for film. Mike and Peter and all the traveling crew and family were equally good sport, and what David captured I think shows something of what it is to travel the world with a tour like this, and get a glimpse

inside that world from that perspective; an inside view of R.E.M. and who we are.

And so; here is to that thing that inspires, elevates, lifts us and makes us think, laugh, talk a little more, and appreciate our time here.

William Klein, Wolfgang Tillmans, Robert Frank, Gary Winogrand, Ryan McGinley, Tina Barney:

Meet David Belisle.

MICHAEL STIPE

IN ATHENS

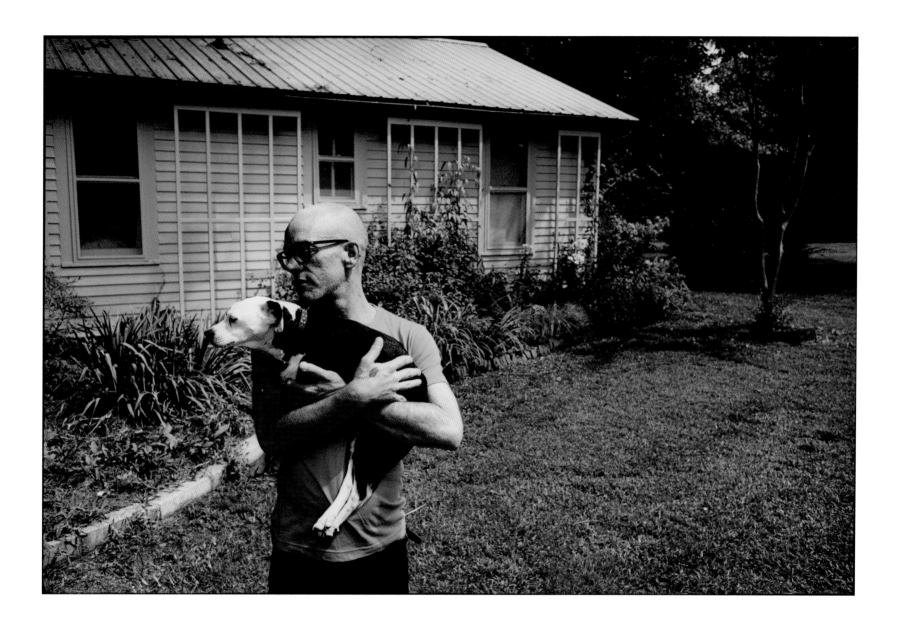

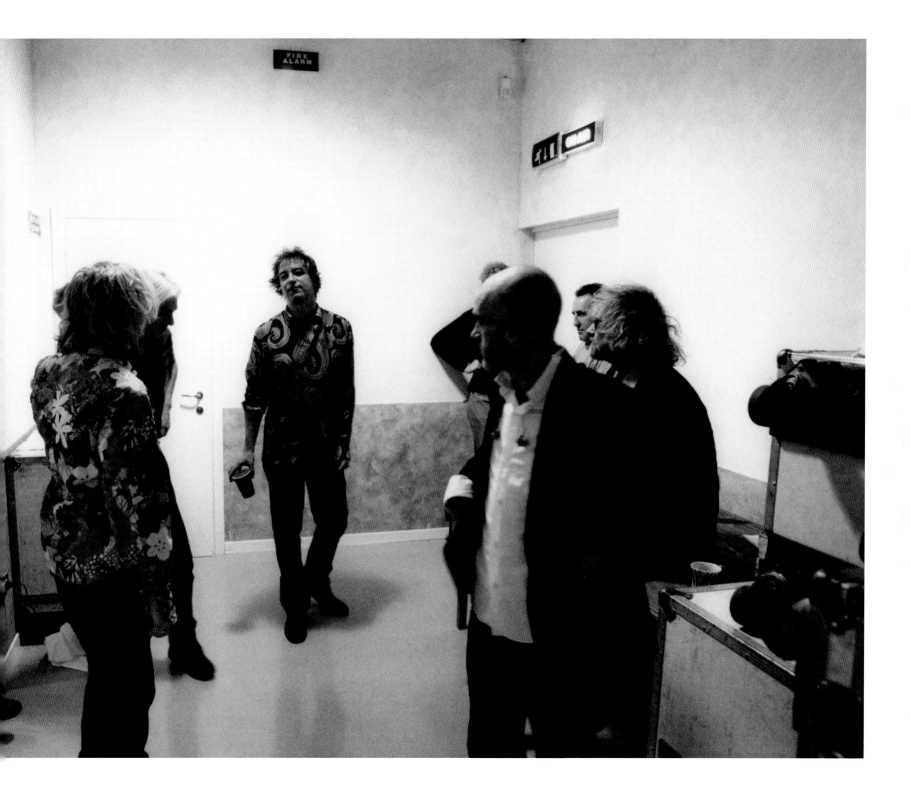

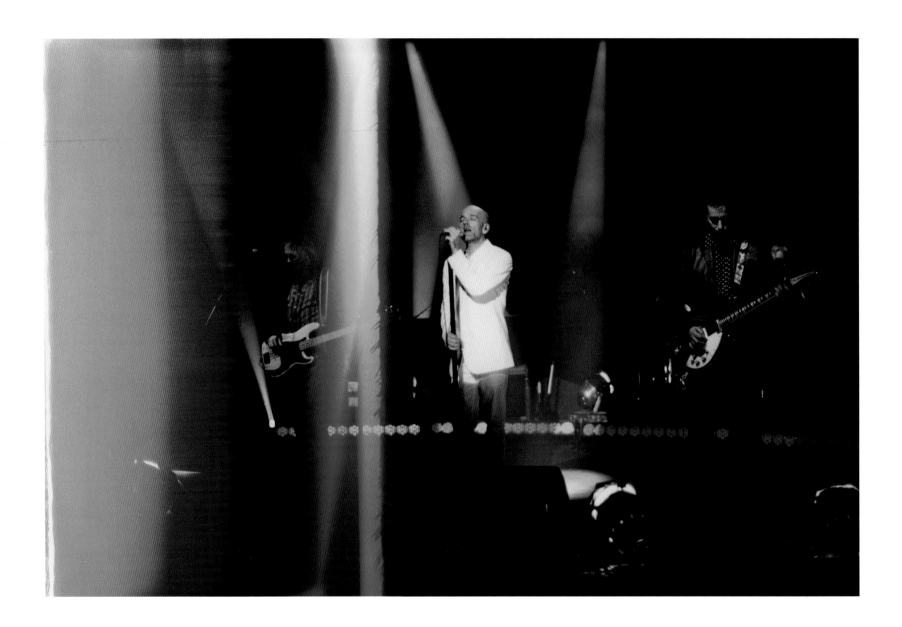

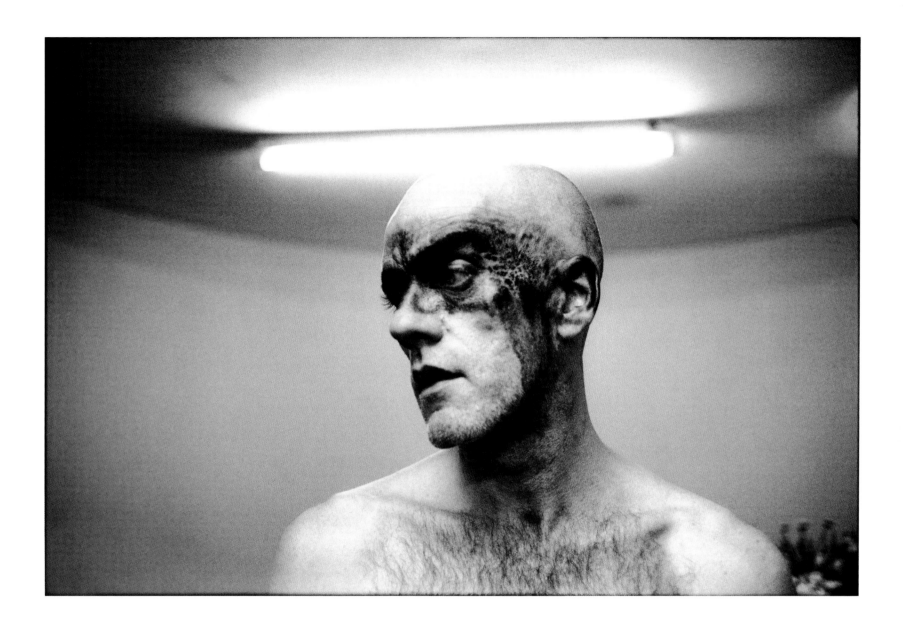

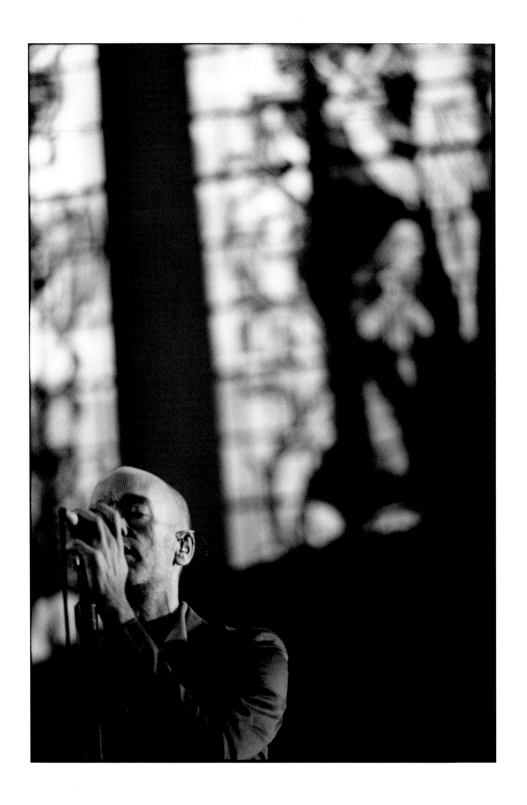

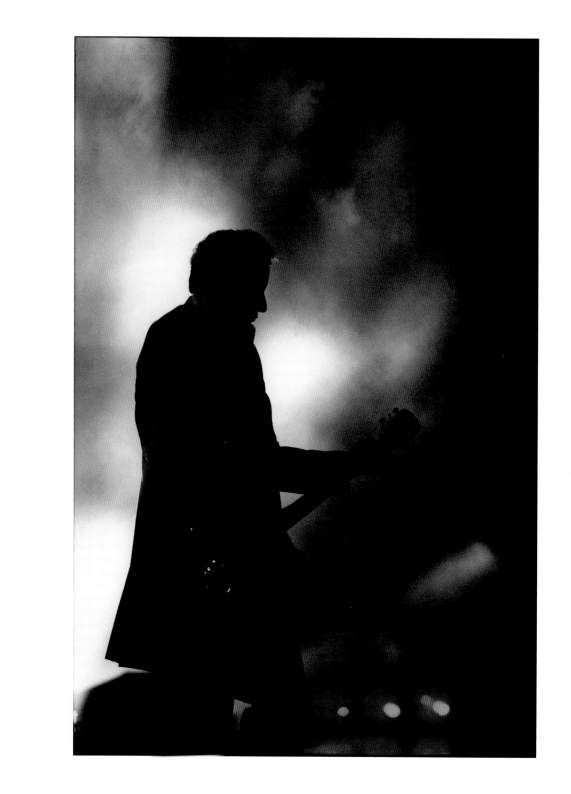

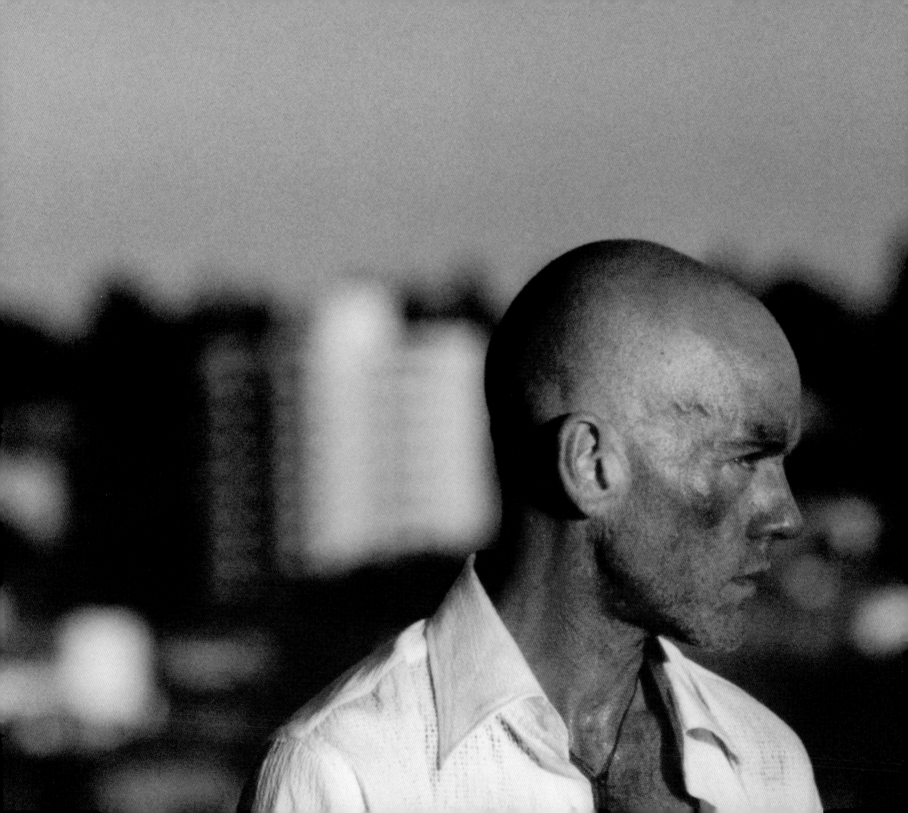

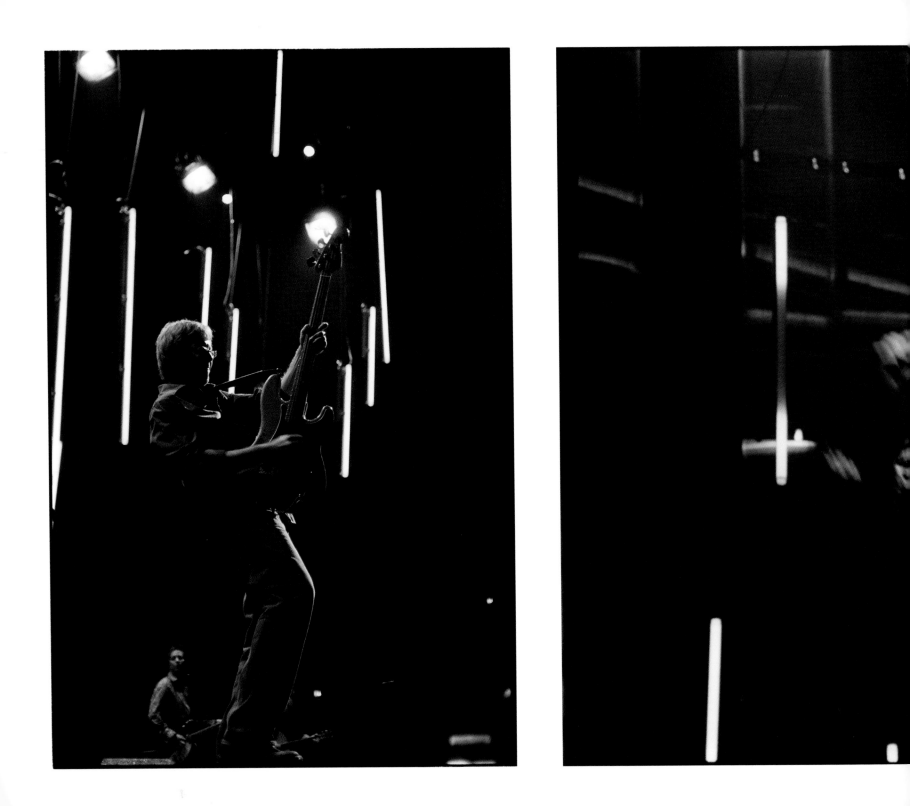

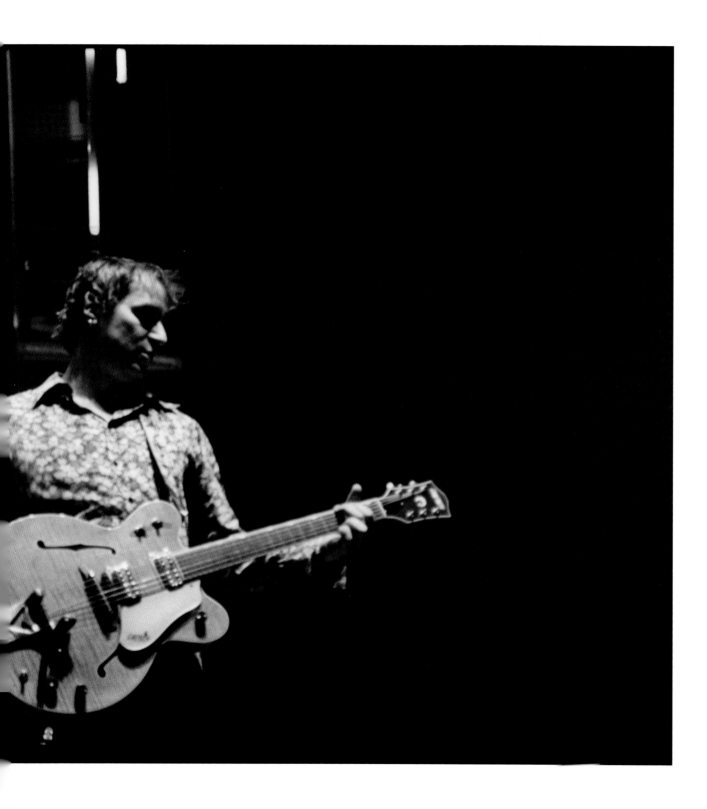

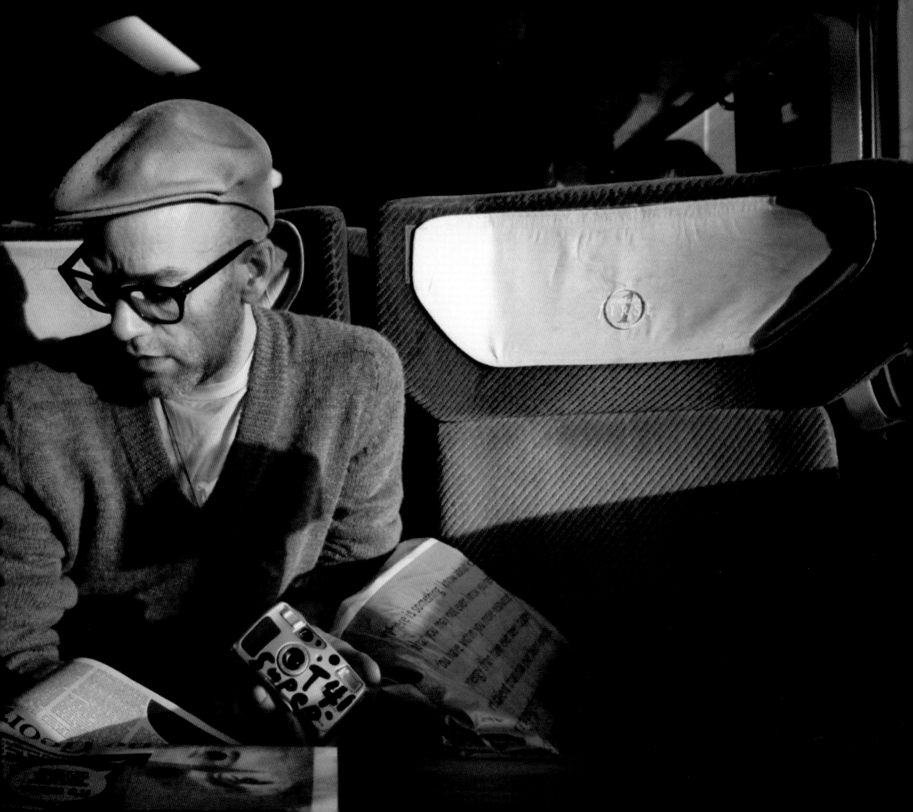

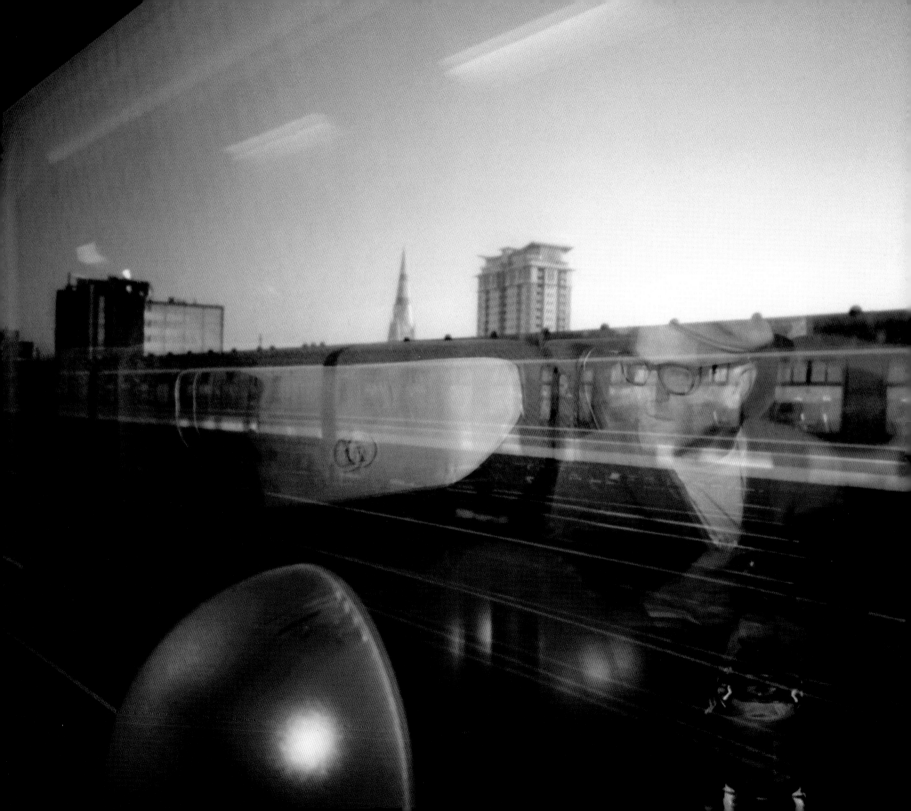

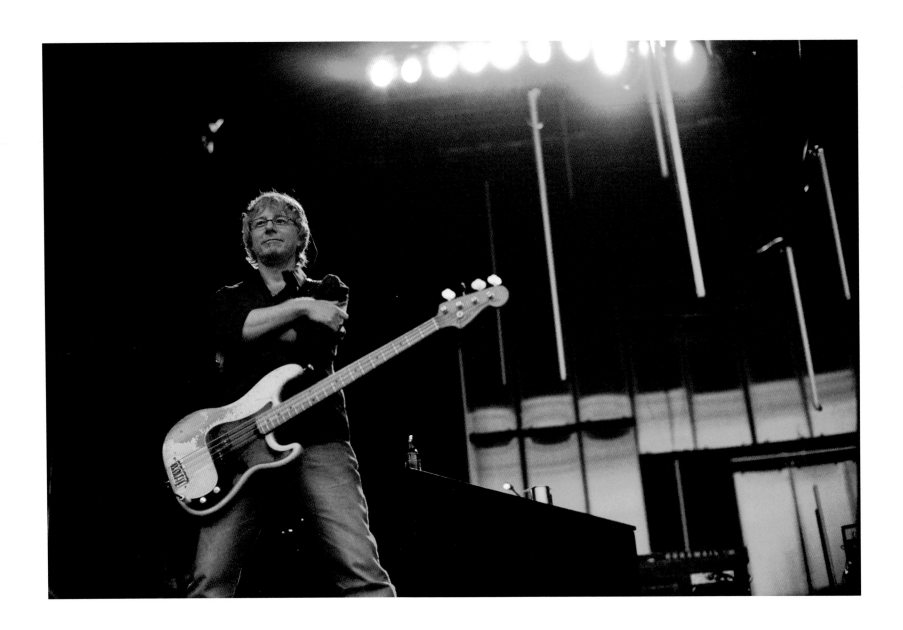

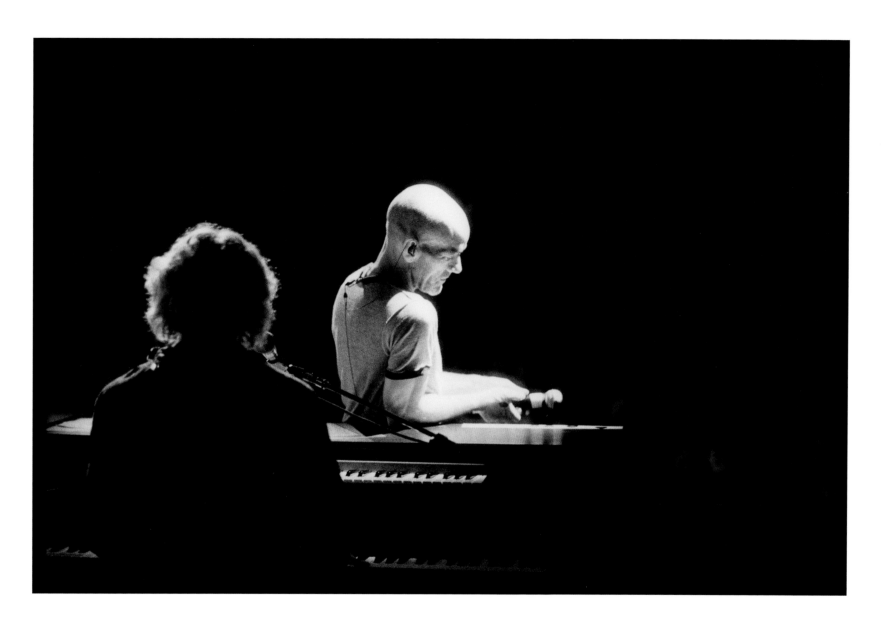

One of those moments

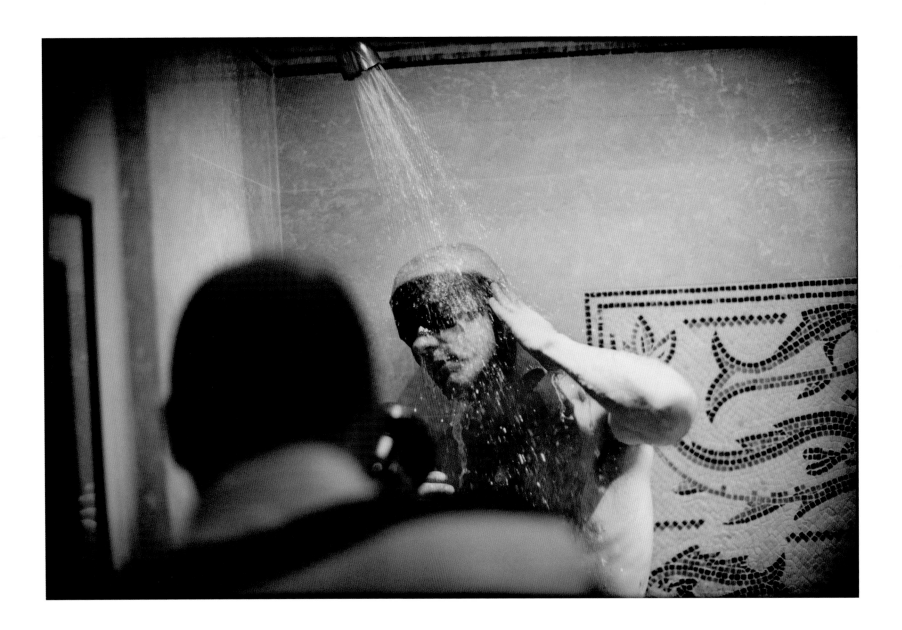

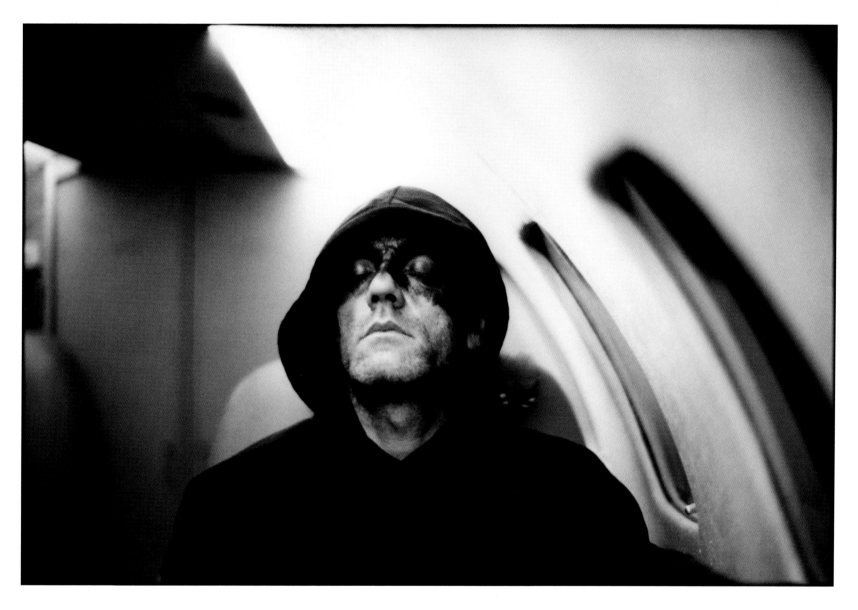

RUNNER OFFSTAGE TO THE
NEXT SHOW

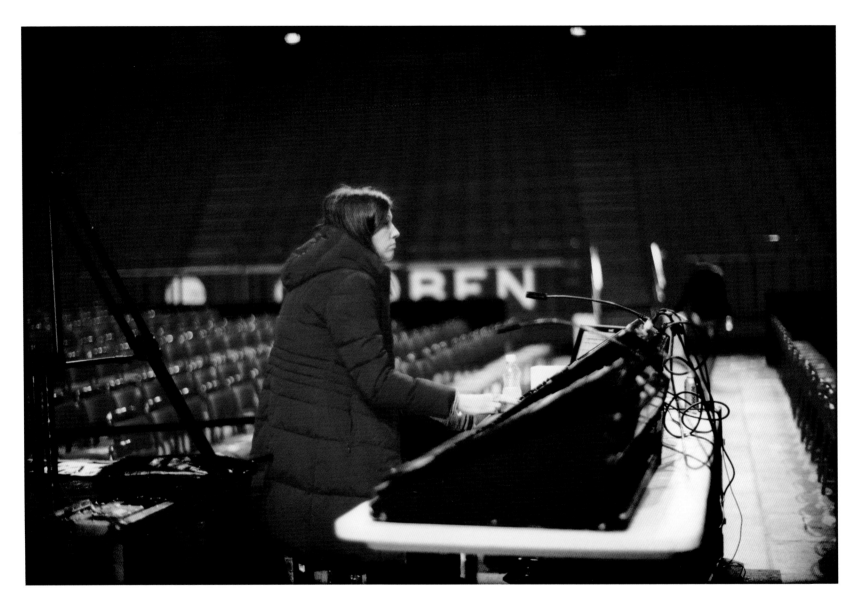

LIGHTING AND STAGE DESIGNER SUSANNE

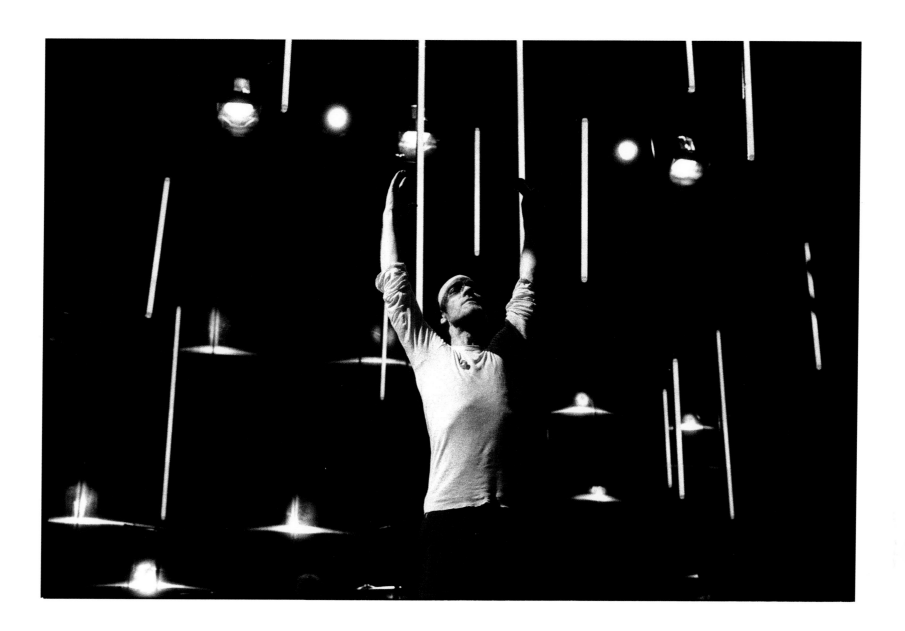

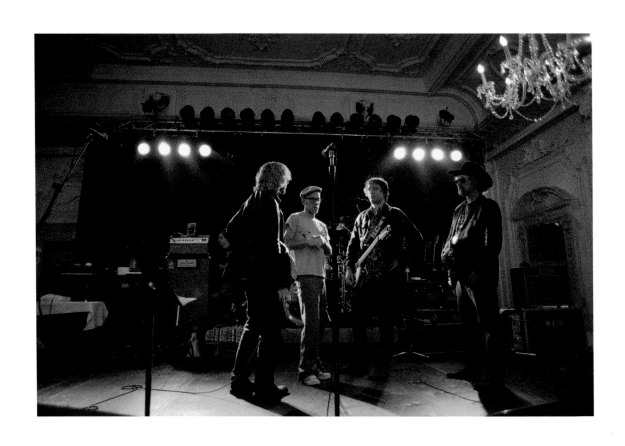

So why aren't you two wearing hats?

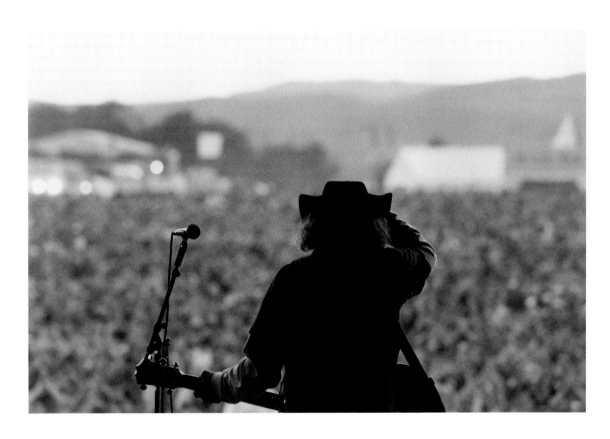

The Young Fresh Fellows
reunion tour was a huge success.

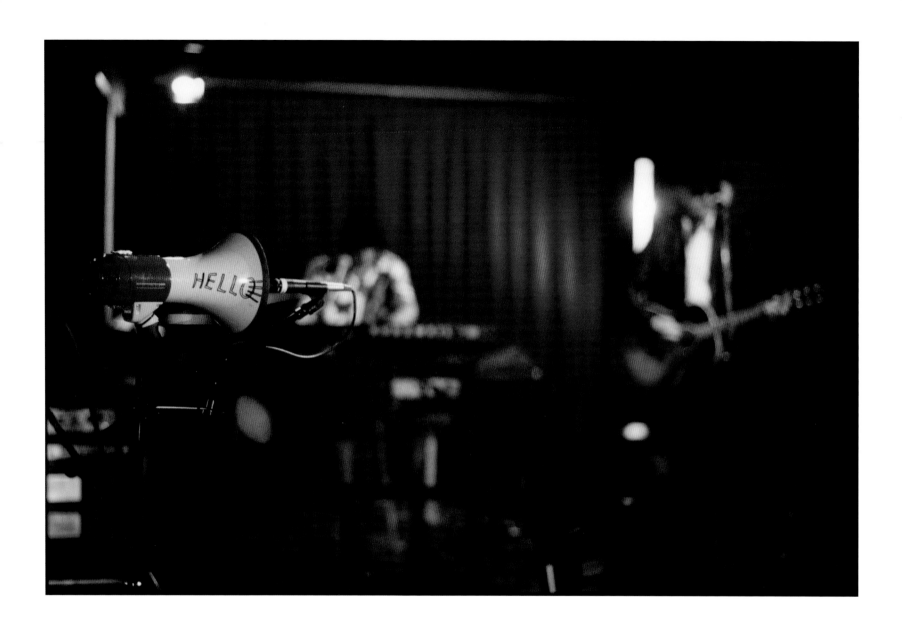

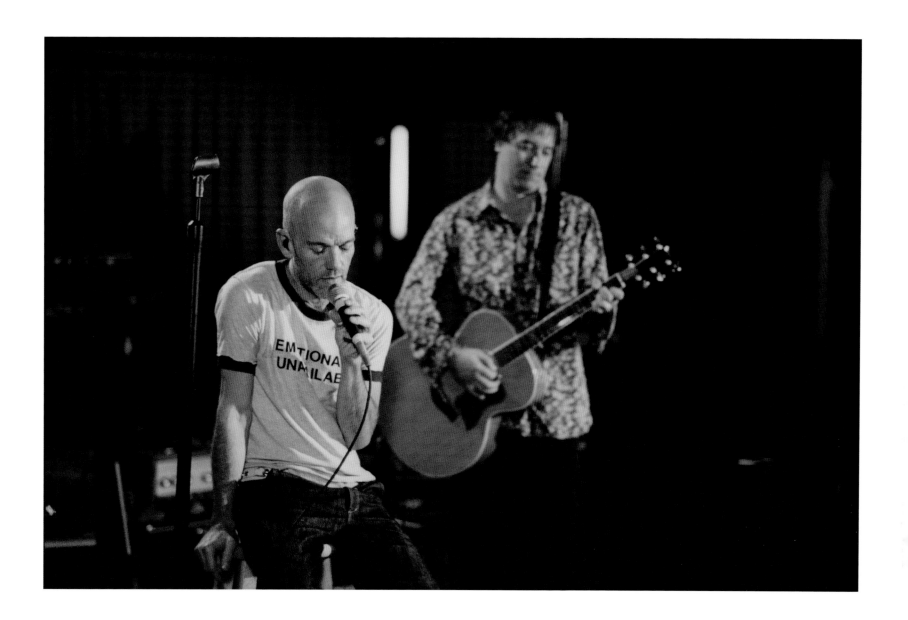

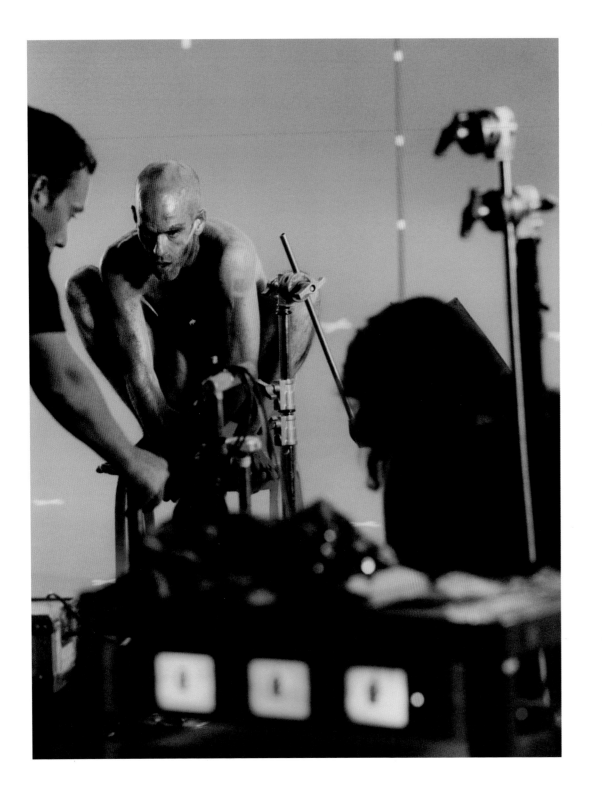

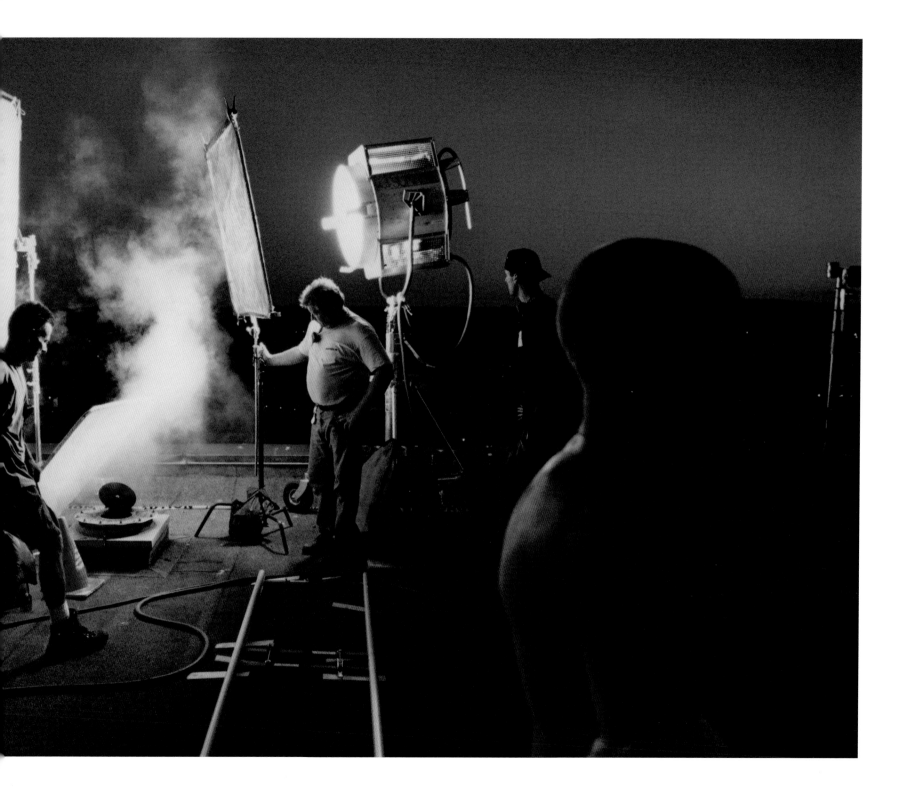

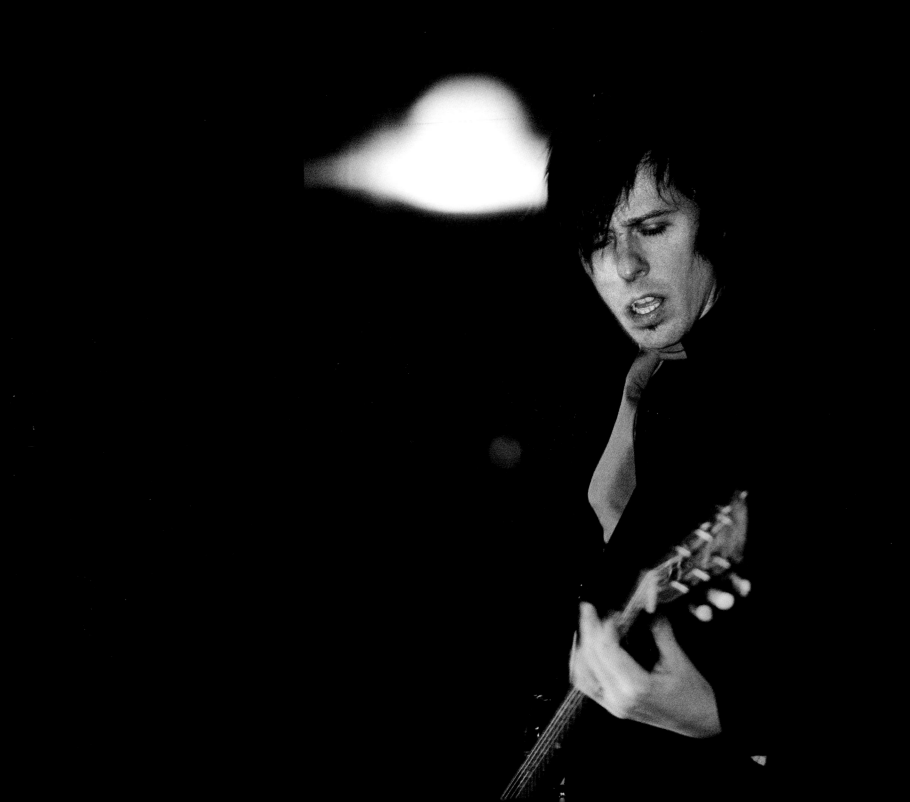

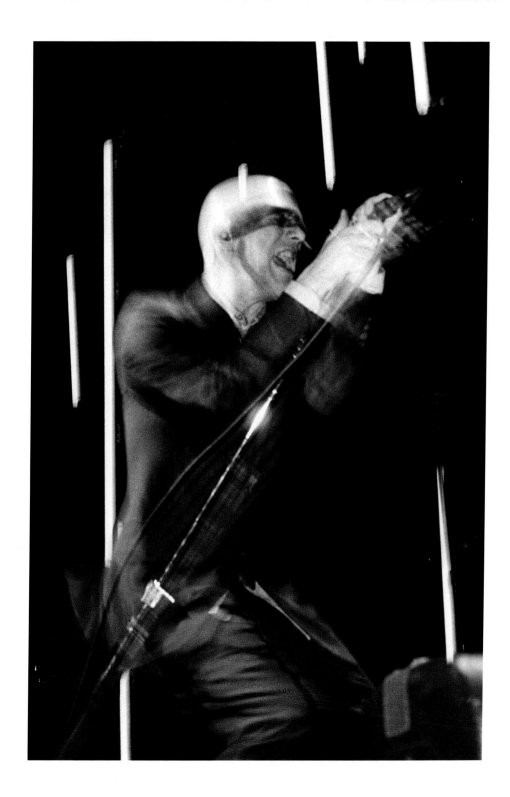

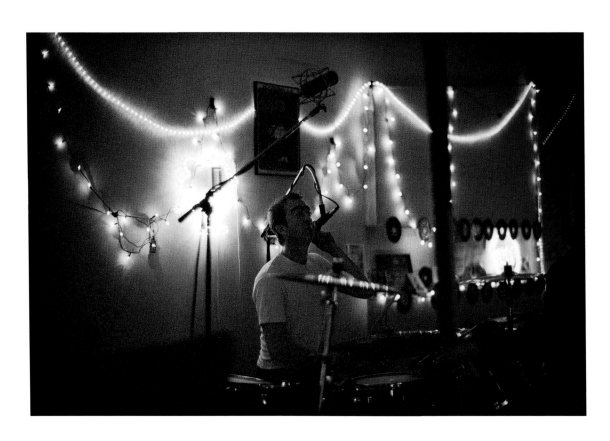

Ol' Shep can still do it

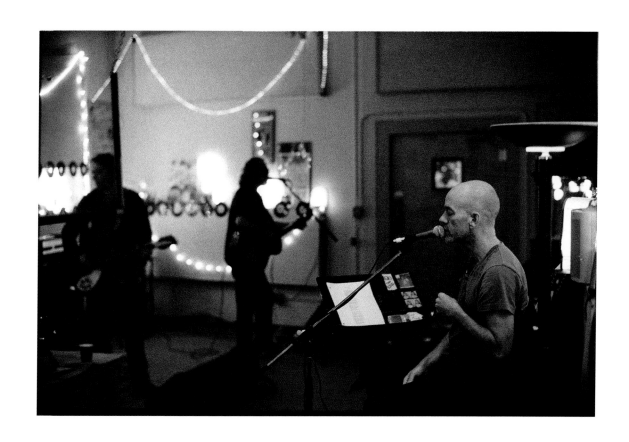

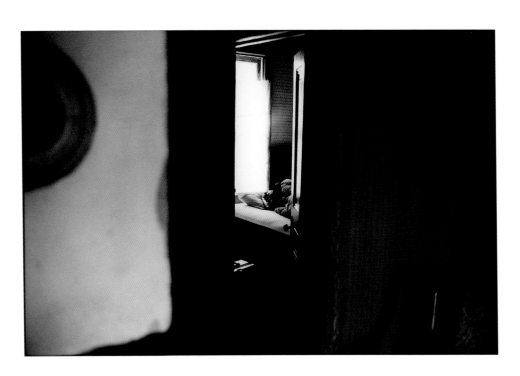

~~THE GUEST CABIN~~ ATH

DAVID AND I ARRIVED AT MY
HOSE AFTER MONTHS ON THE ROAD,
MIDDLE OF THE NIGHT. I COULDN'T
REMEMBER THE SECURITY CODE, SO
WE HAD TO BREAK INTO THE GUEST
CABIN AND SLEEP THERE.

AND ~~AND~~ IT WAS TOO LATE
TO CALL ANYBODY.

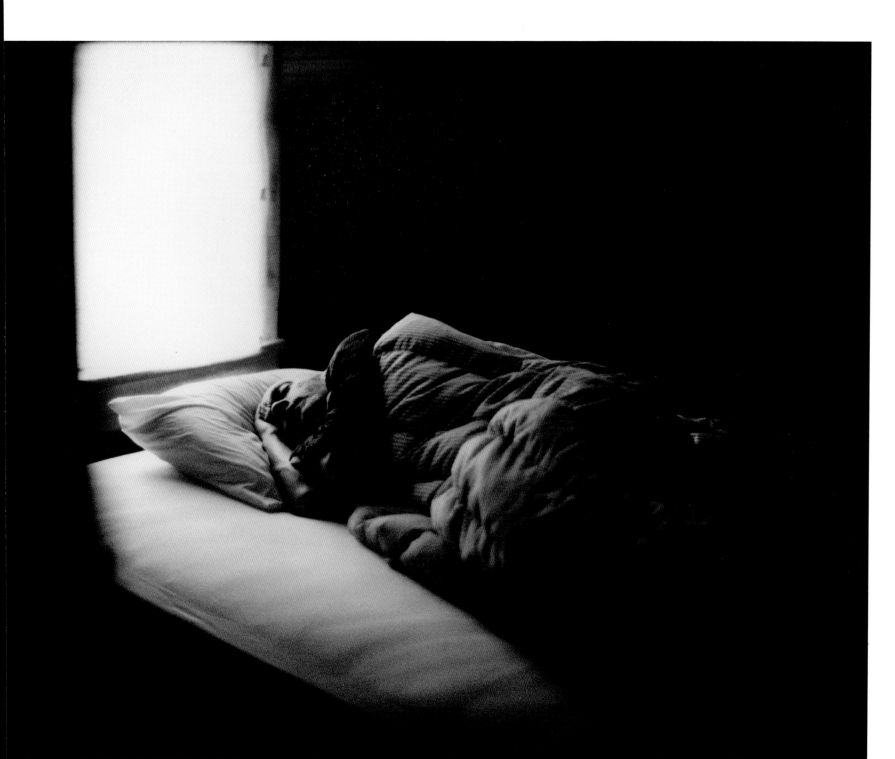

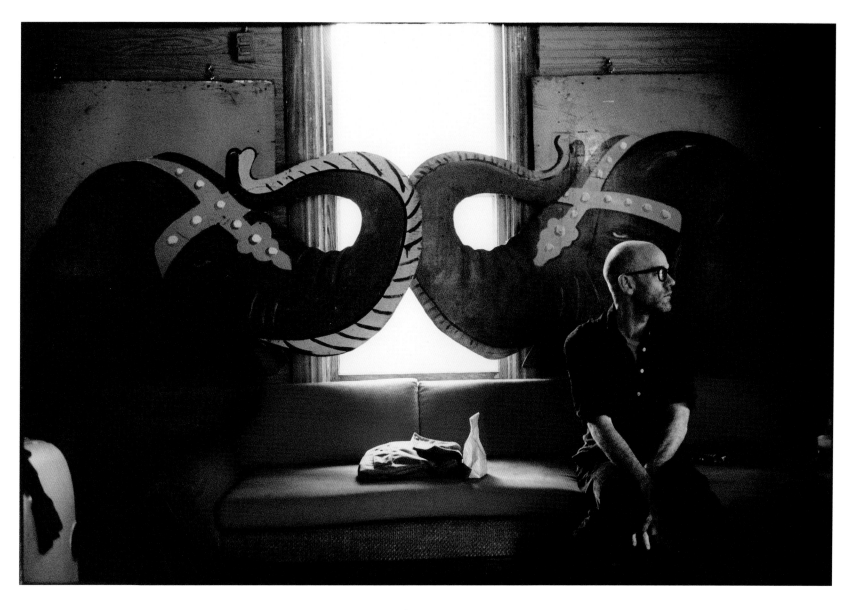

ME AT HOME IN ATHENS

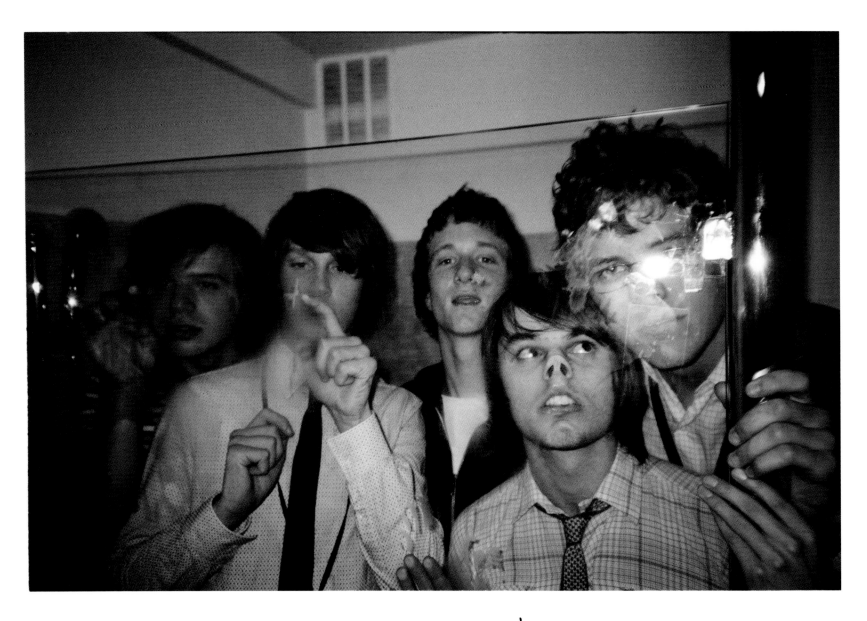

Tired from sleeping!

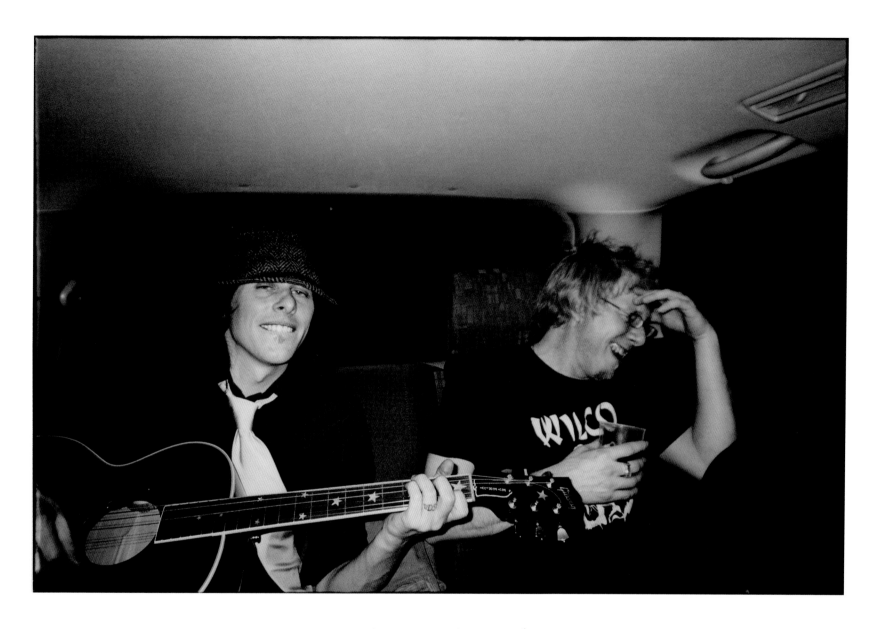

Rocking the Checks

LONDON

WITH THOM

~~Lubbock~~

LONDON

WITH THOM

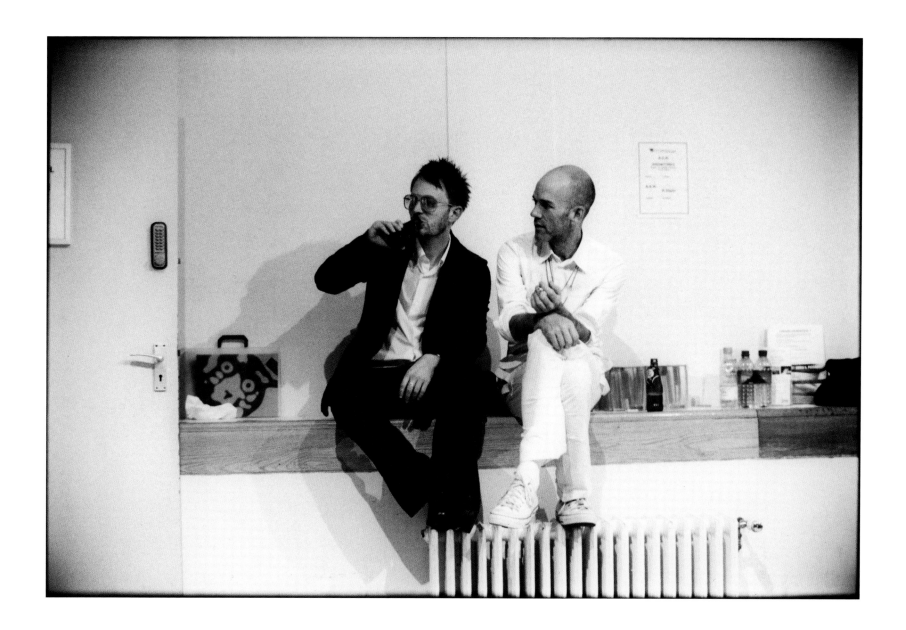

SUPER FABULOUS
TV SET
IN GERMANY;
MR BILL RIEFLIN
ON DRUMS,
SCOTT McCAUGHEY
ON GTR.

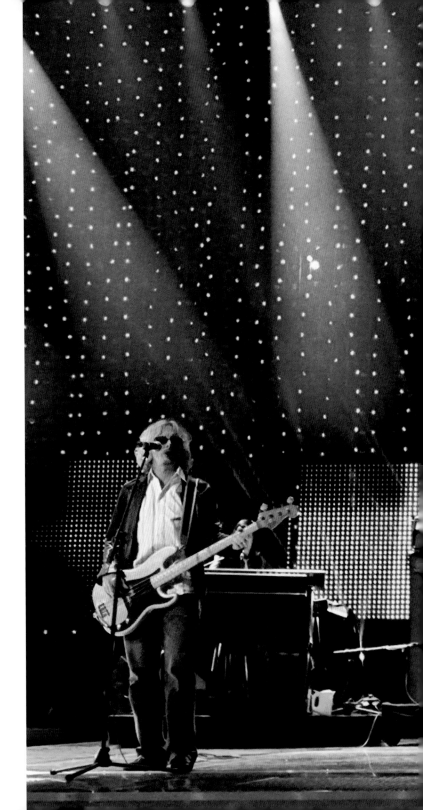

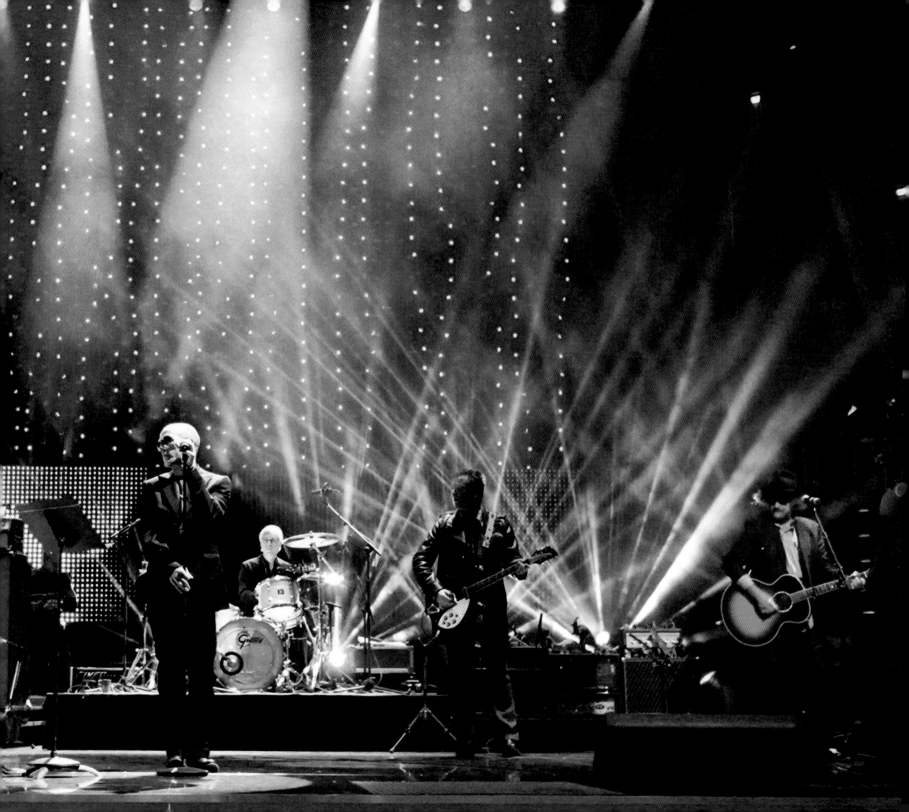

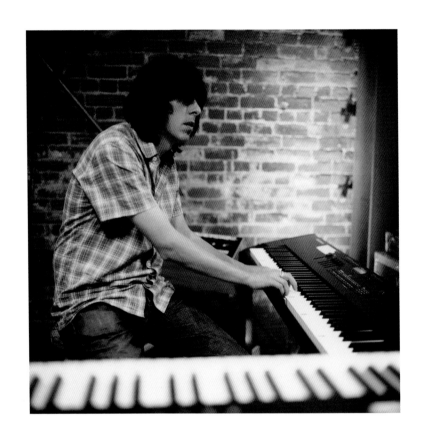

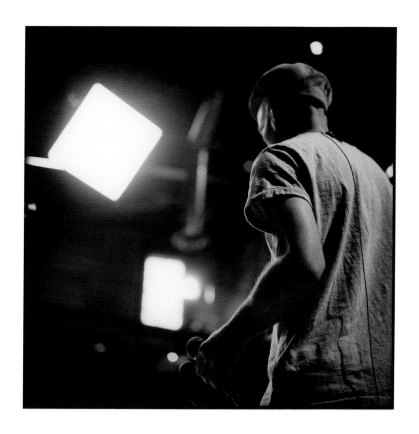

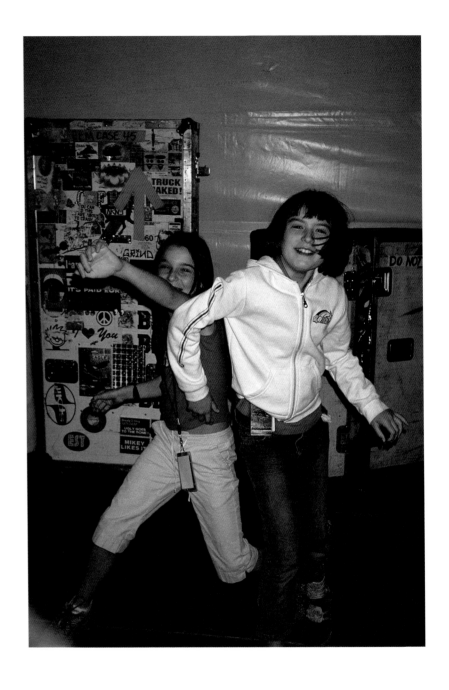

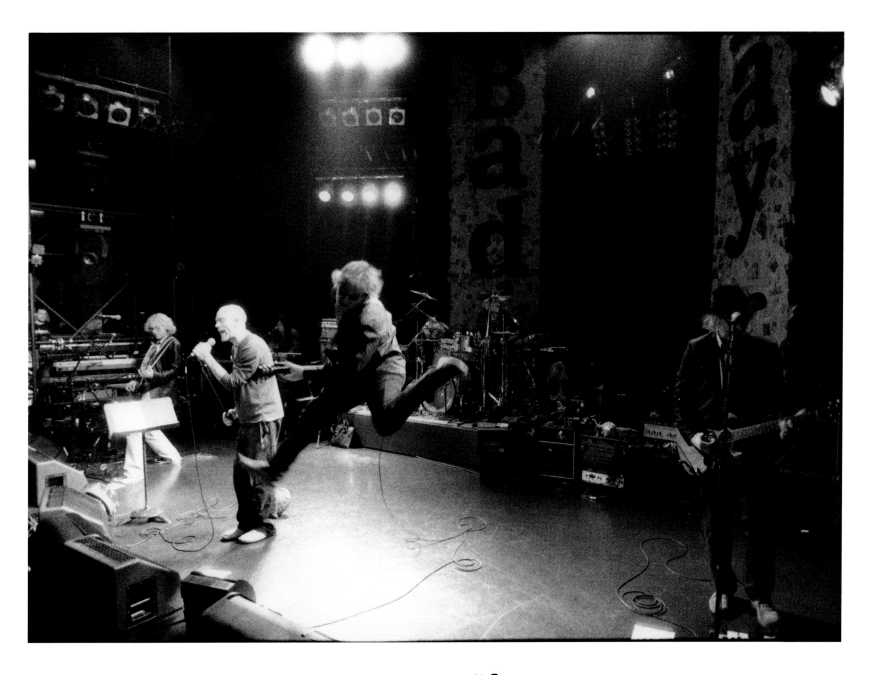

How high can you fly?
Dad doing one of his crazy-high kicks.

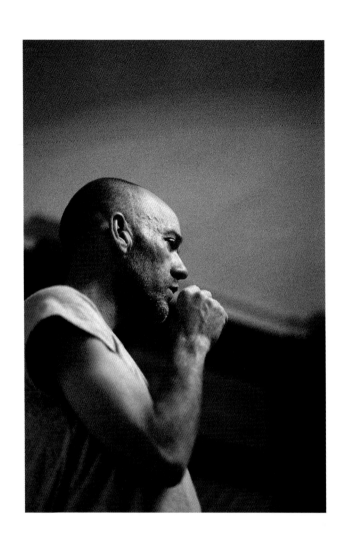

TREAD GENTLY AND CARRY A BIG HAT

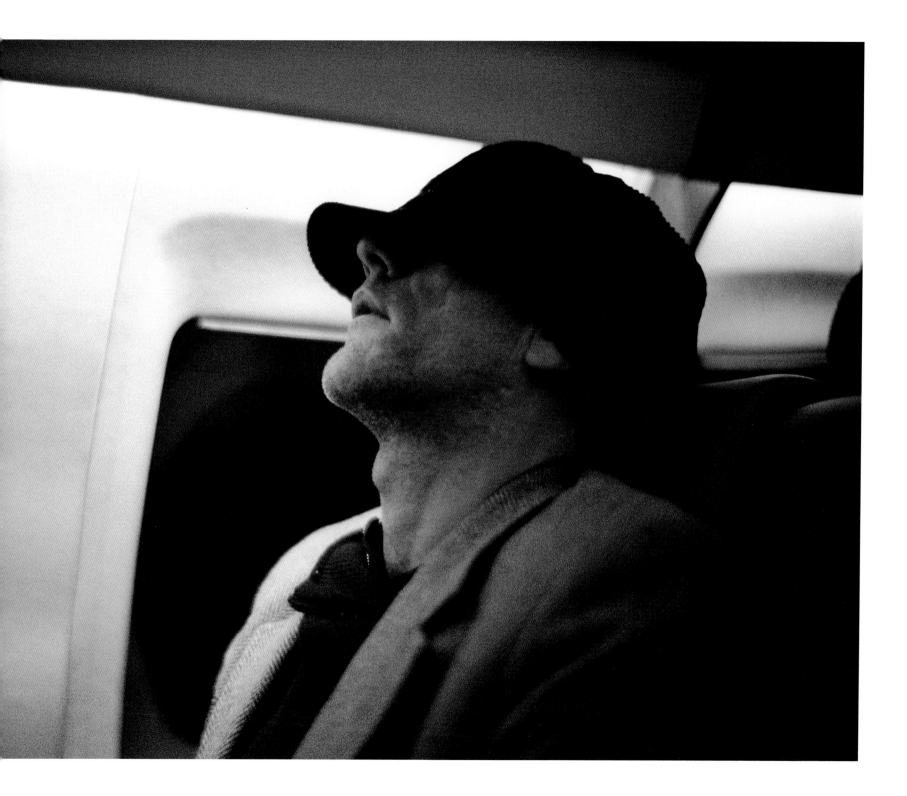

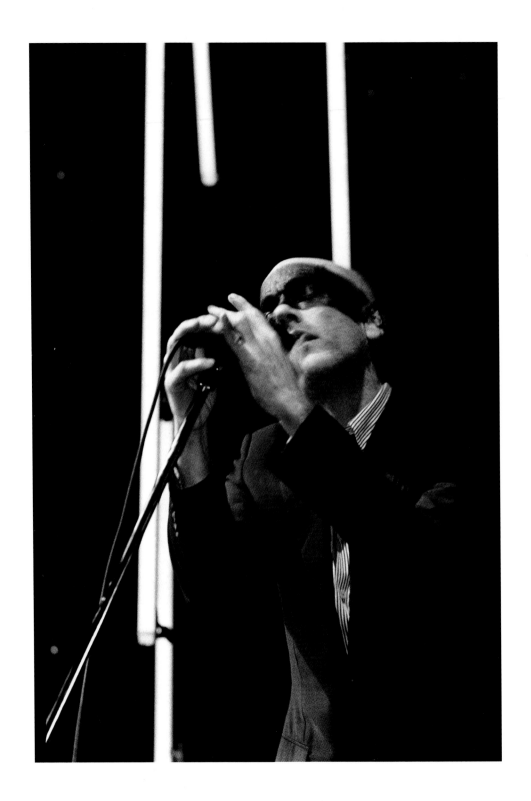

ATH
ROADCASE

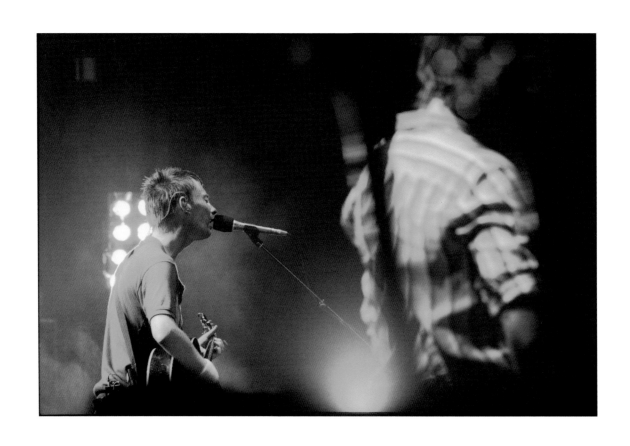

VANCOUVER RADIOHEAD
AND R.E.M. WERE PLAYING TOGETHER,
START OF OUR TOUR. 2003

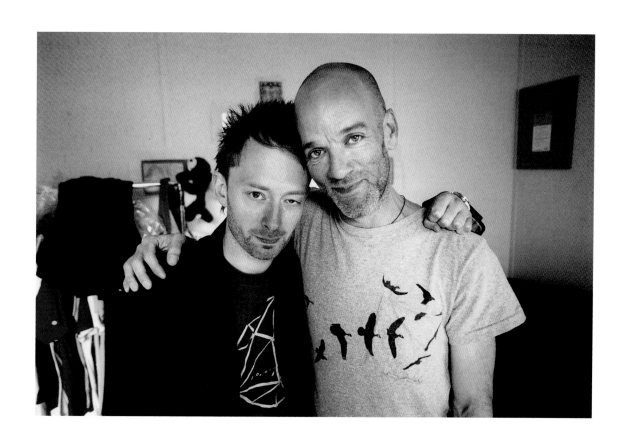

ID BEEN UP FOR BASICALLY 3 DAYS
SHOOTING THE ANIMAL VIDEO.

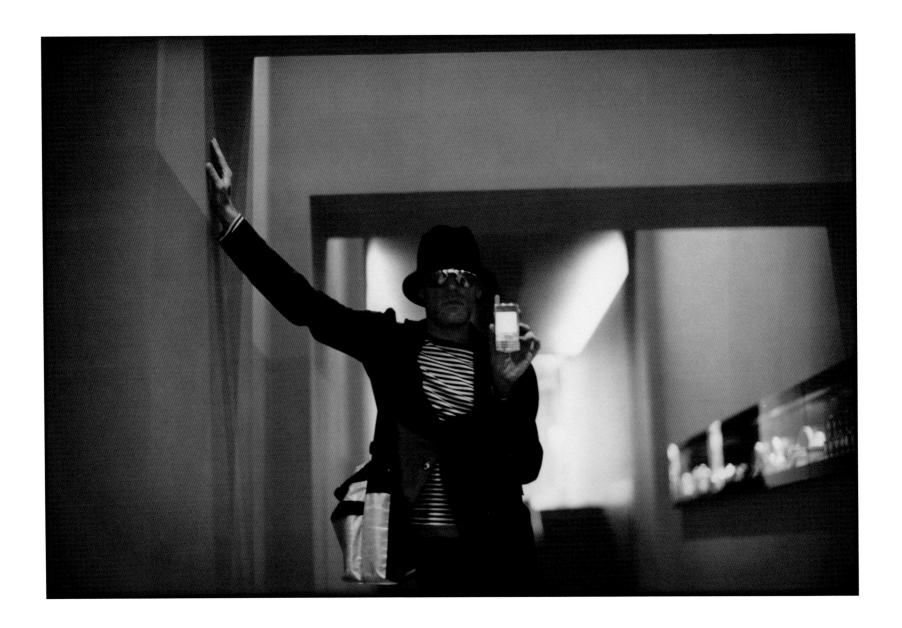

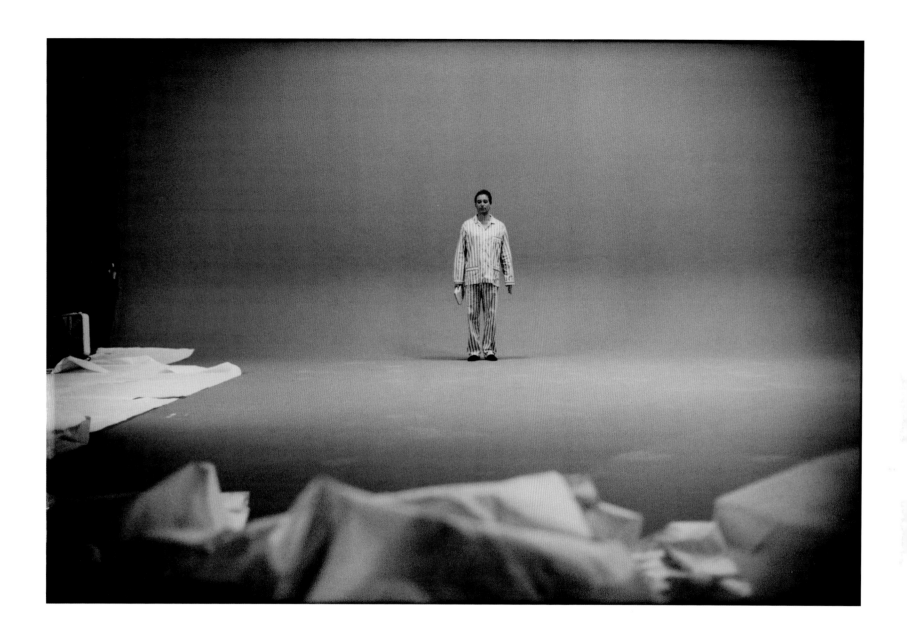

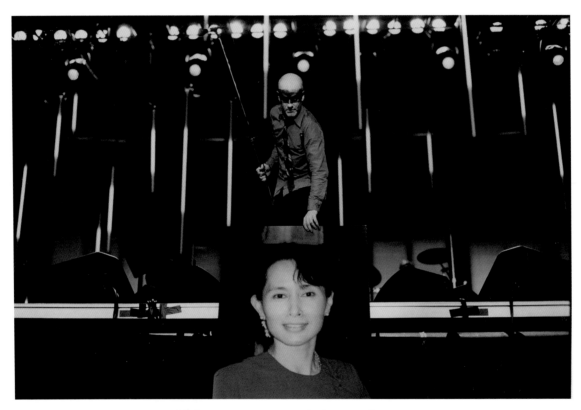

ON THE OCCASION OF THE 60TH
BIRTHDAY OF AUNG SAN SUU KYI,
DUBLIN

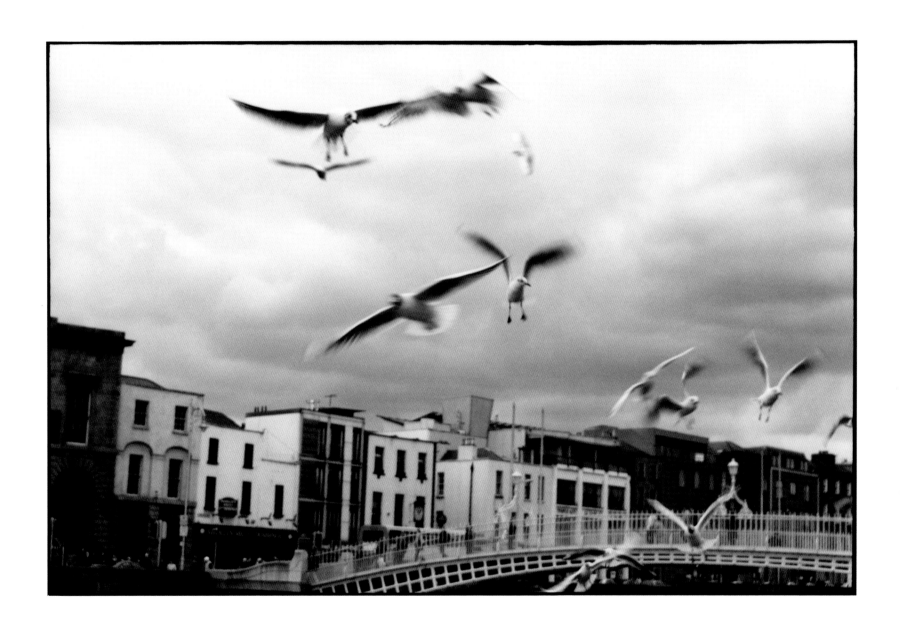

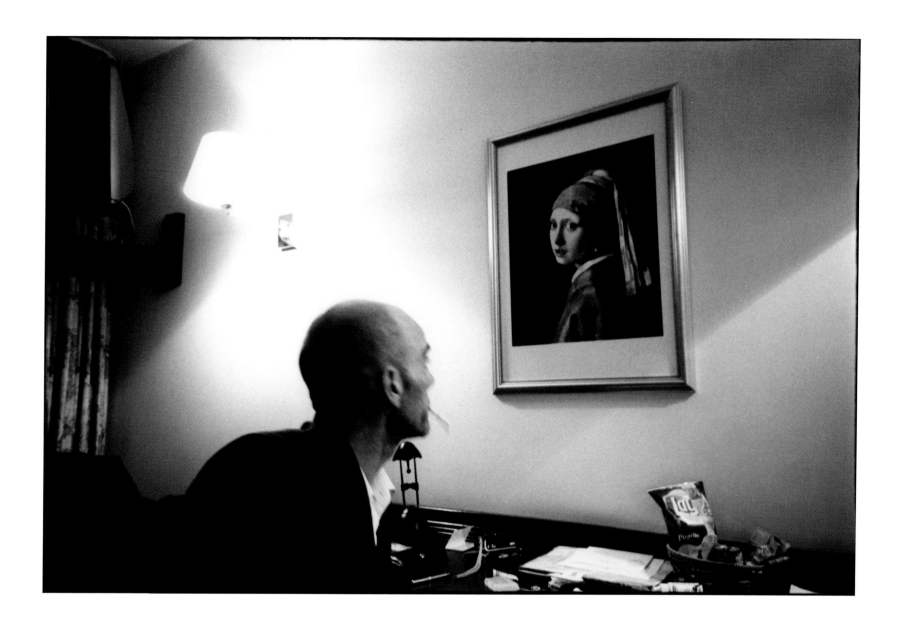

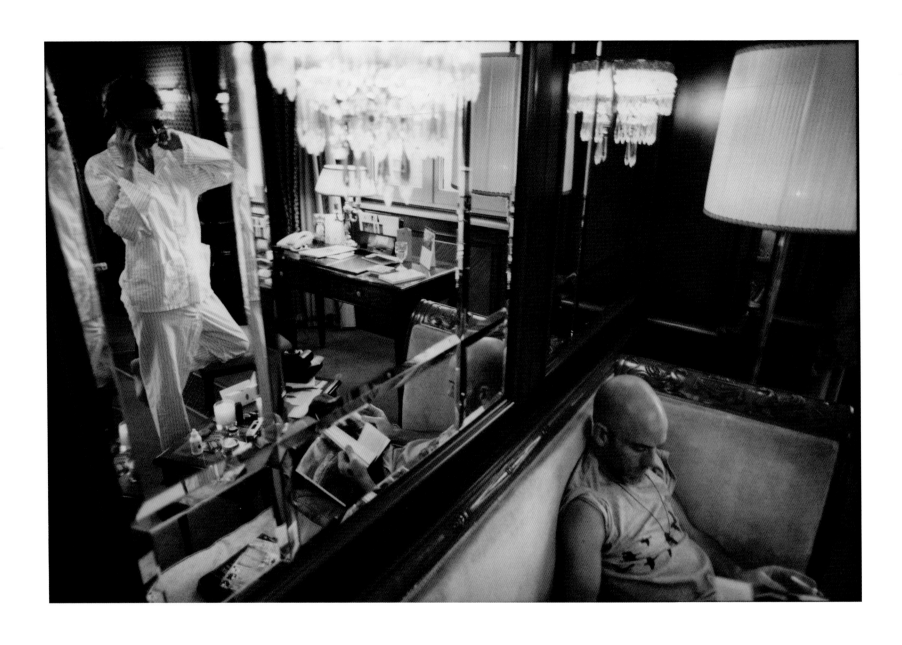

MILAN 2003

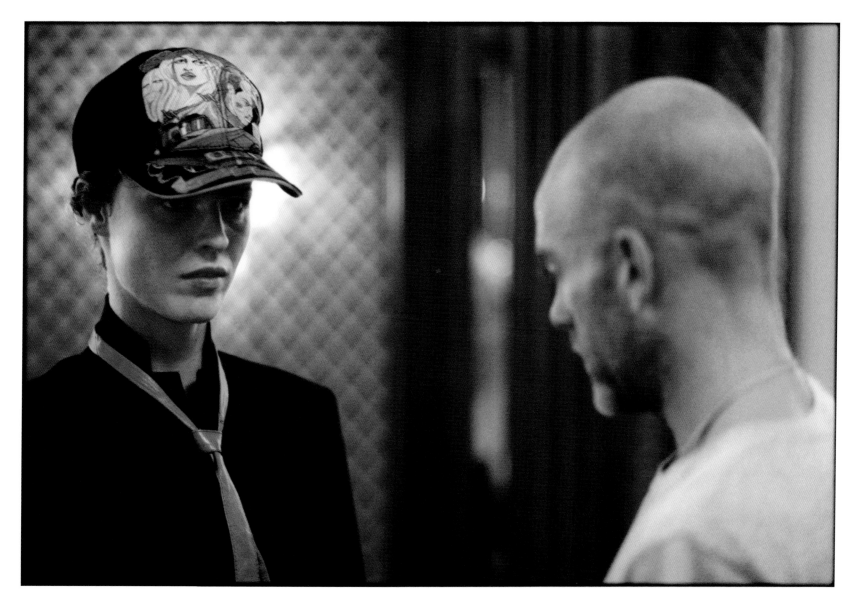

EVA HERZIGOVA

I SHOT EVA IN ONLY
MY CLOTHES AND MAKEUP.

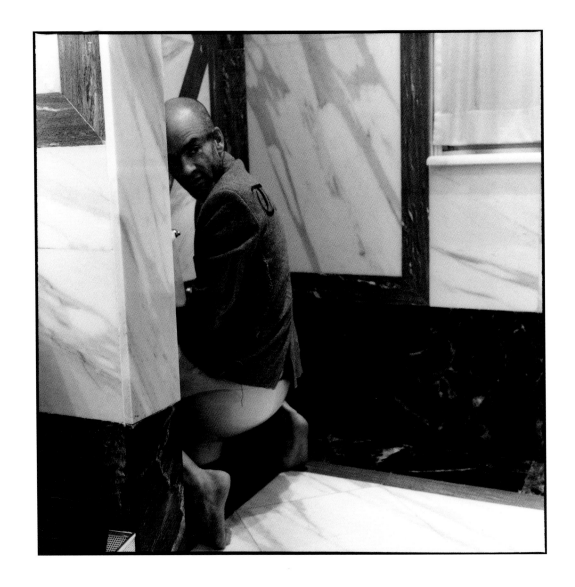

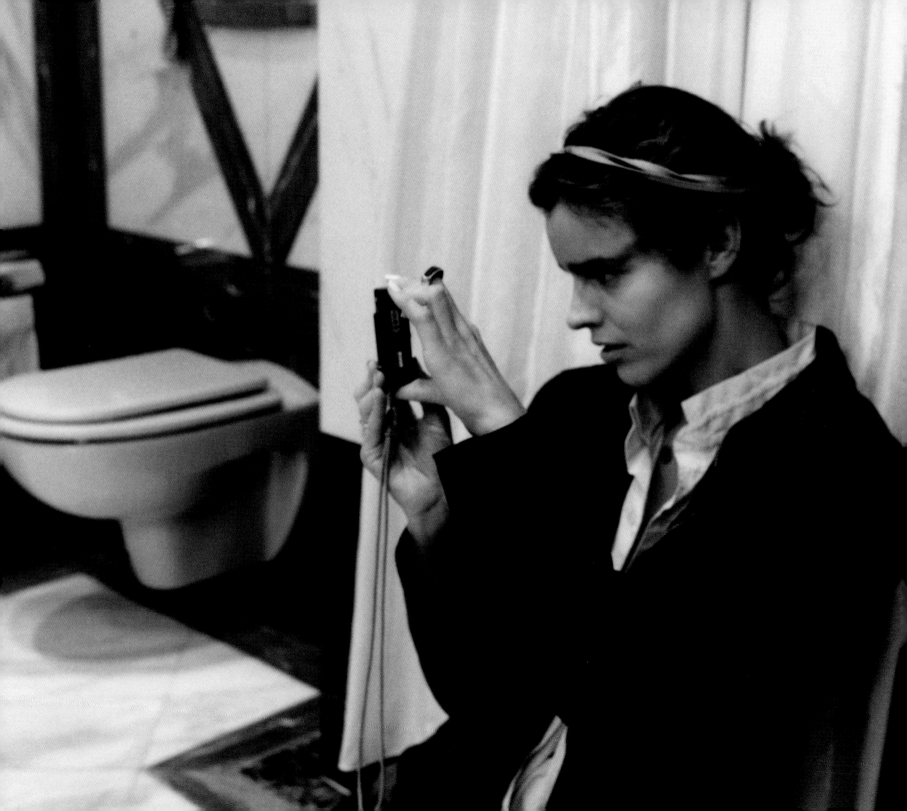

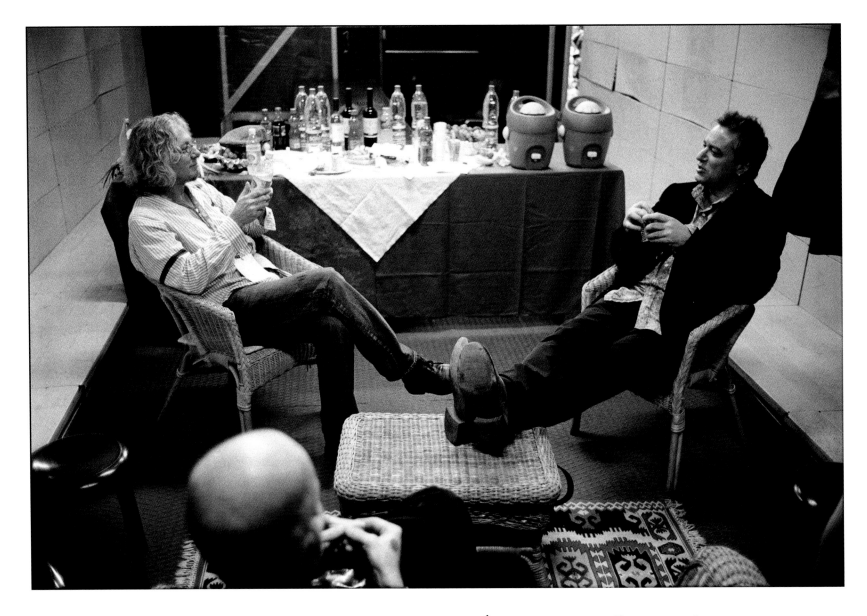

THE PARTS THAT PEOPLE DON'T KNOW ABOUT, JUST SITTING AROUND
LIKE BUMPS ON A LOG. BACKSTAGE SOMEWHERE.

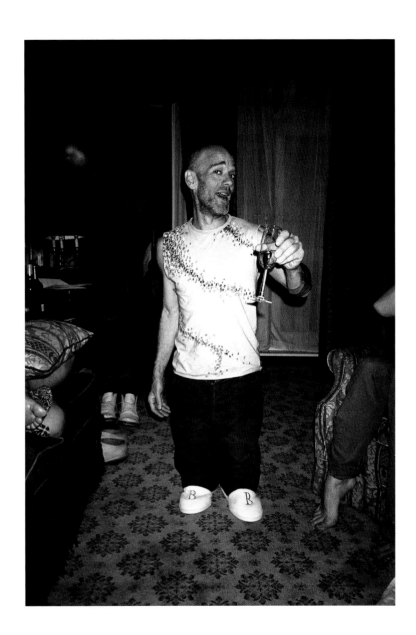

He wears make-up on stage
so you dont notice his
legs.

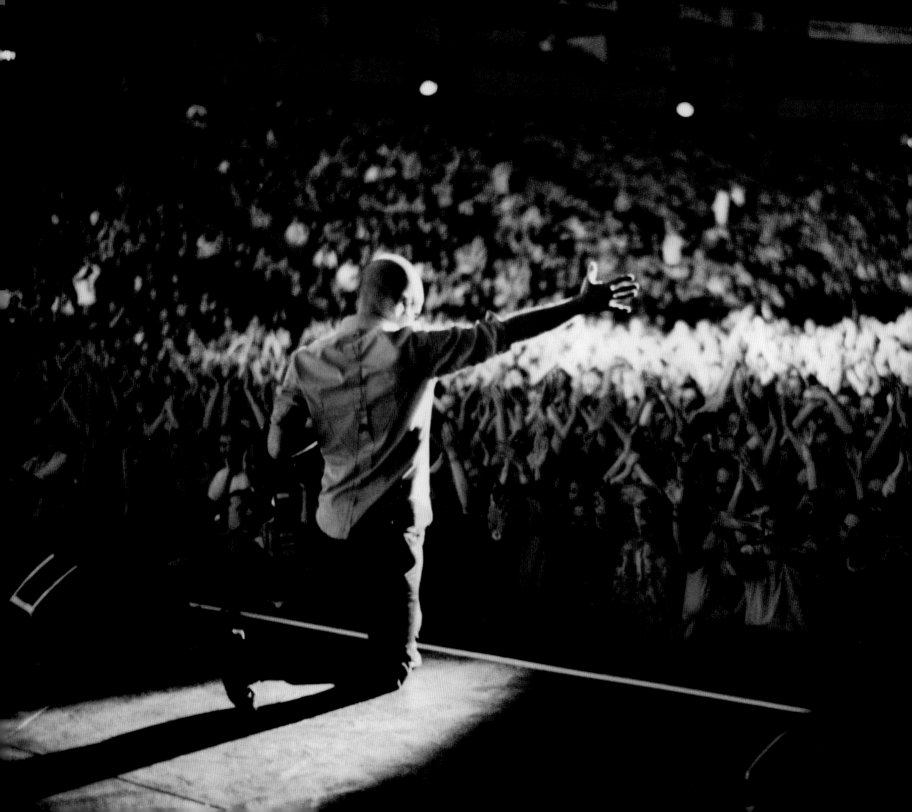

My Feet
ANIMAL VIDEO SHOOT

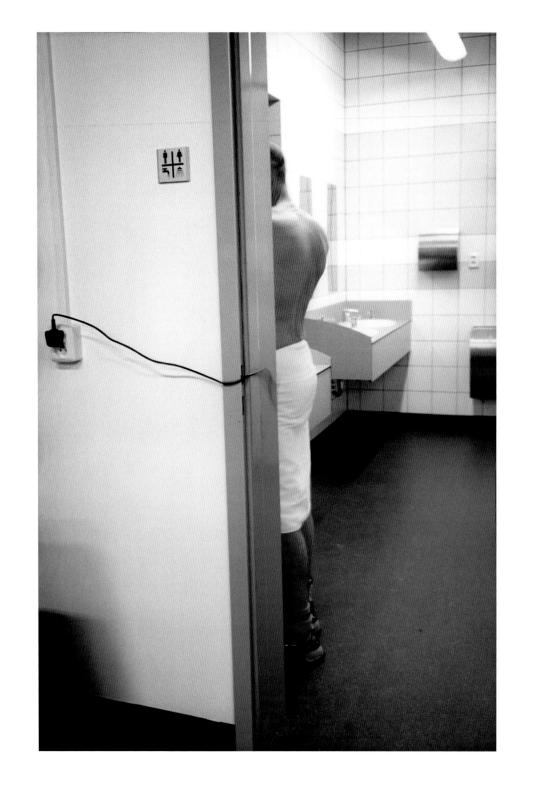

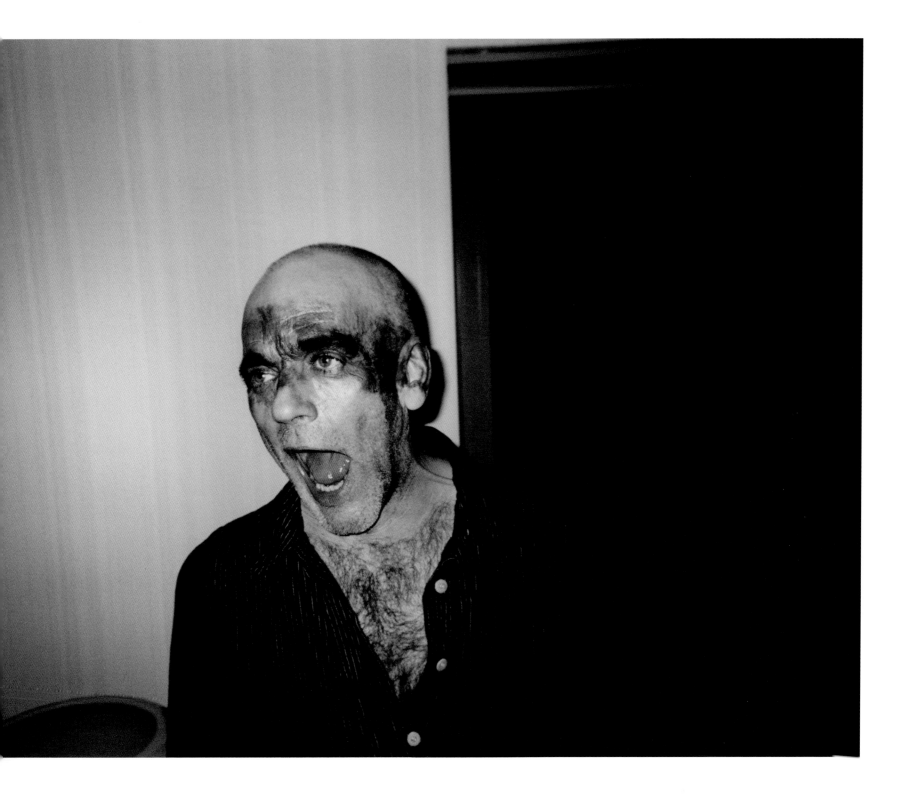

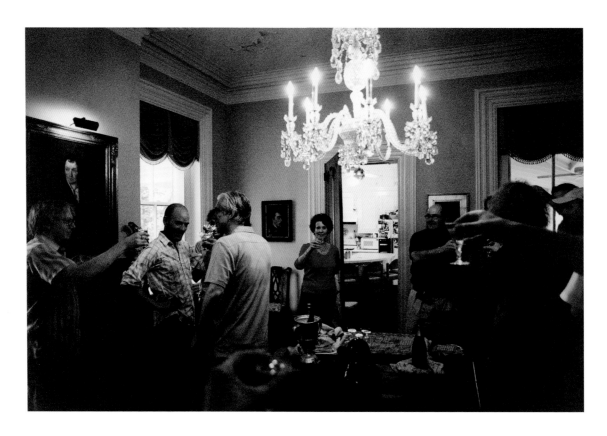

The traditional "tour send-off"
at Margie's house in Athens

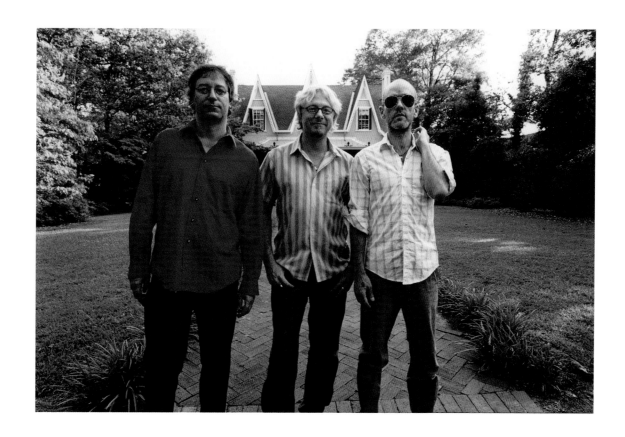

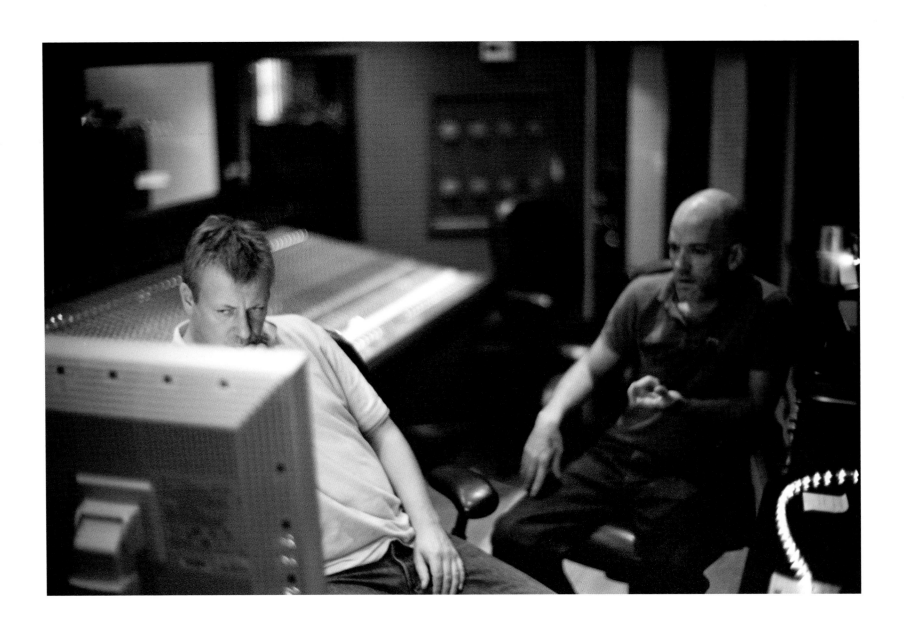

Anything but Fox News!

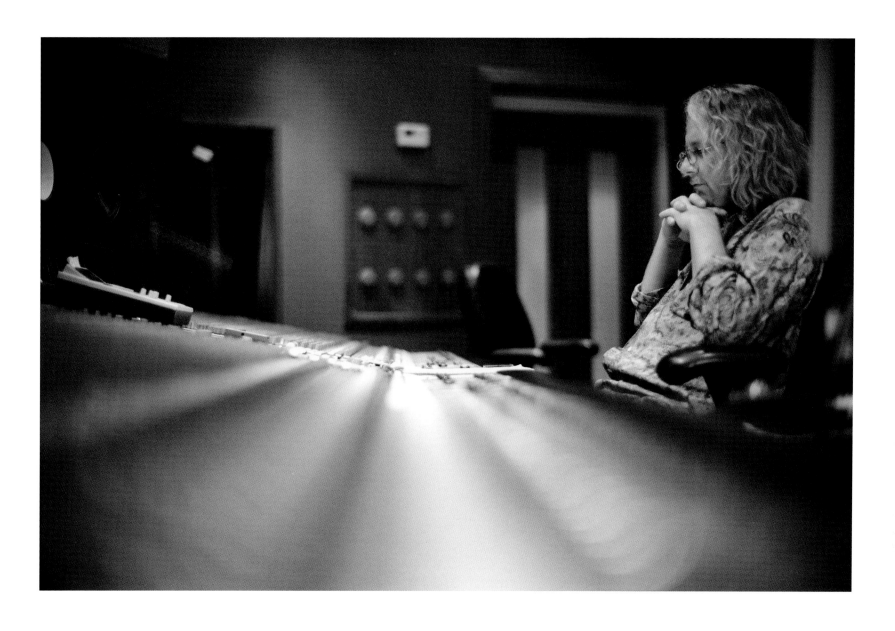

Too many buttons!

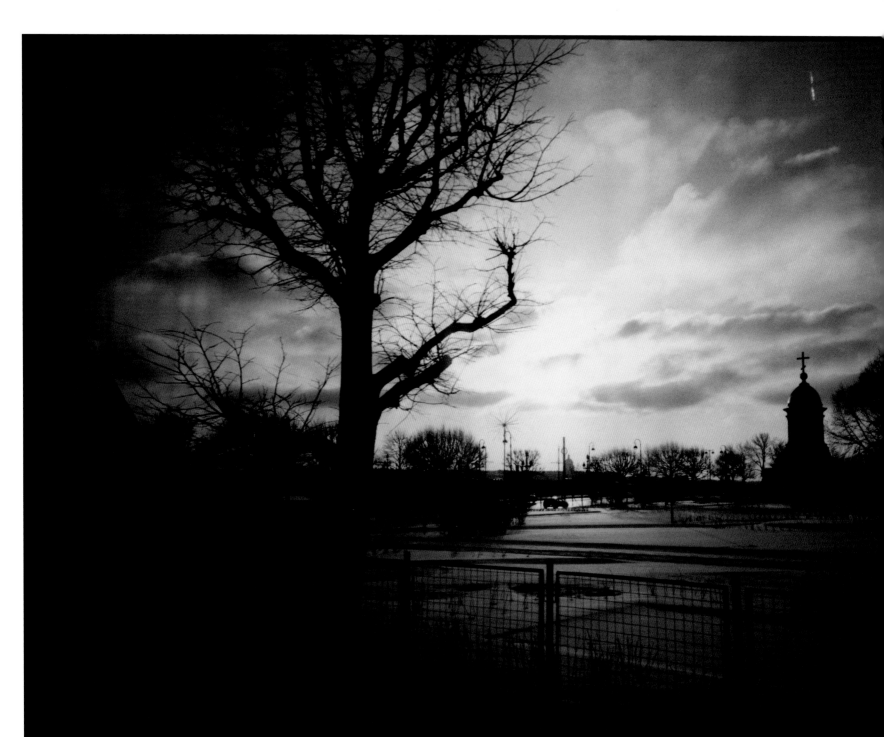

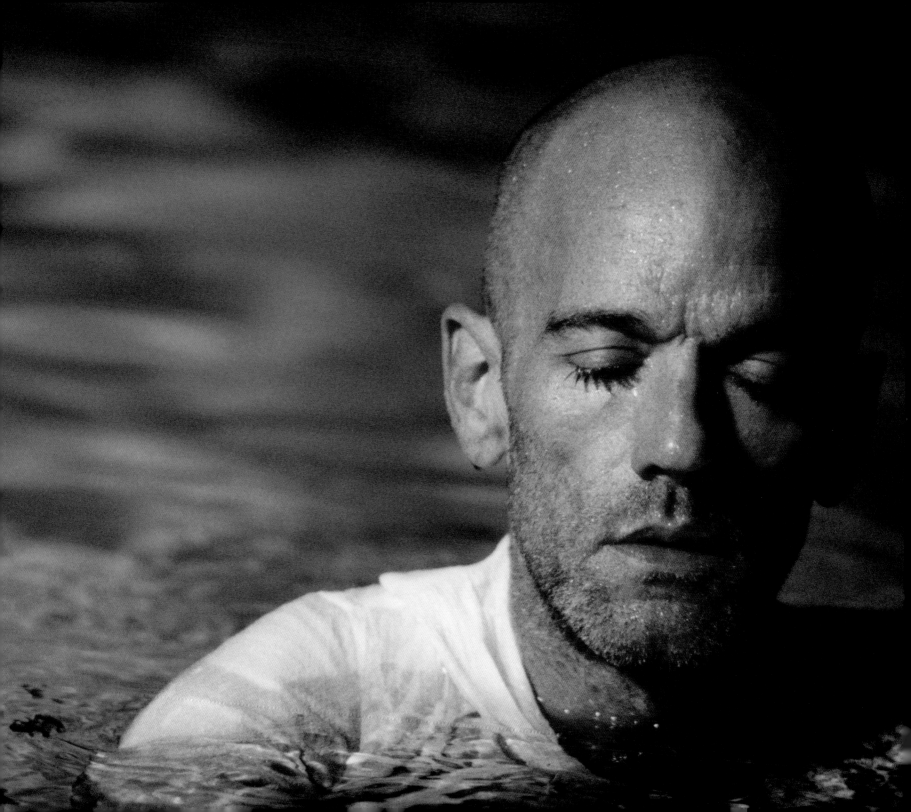

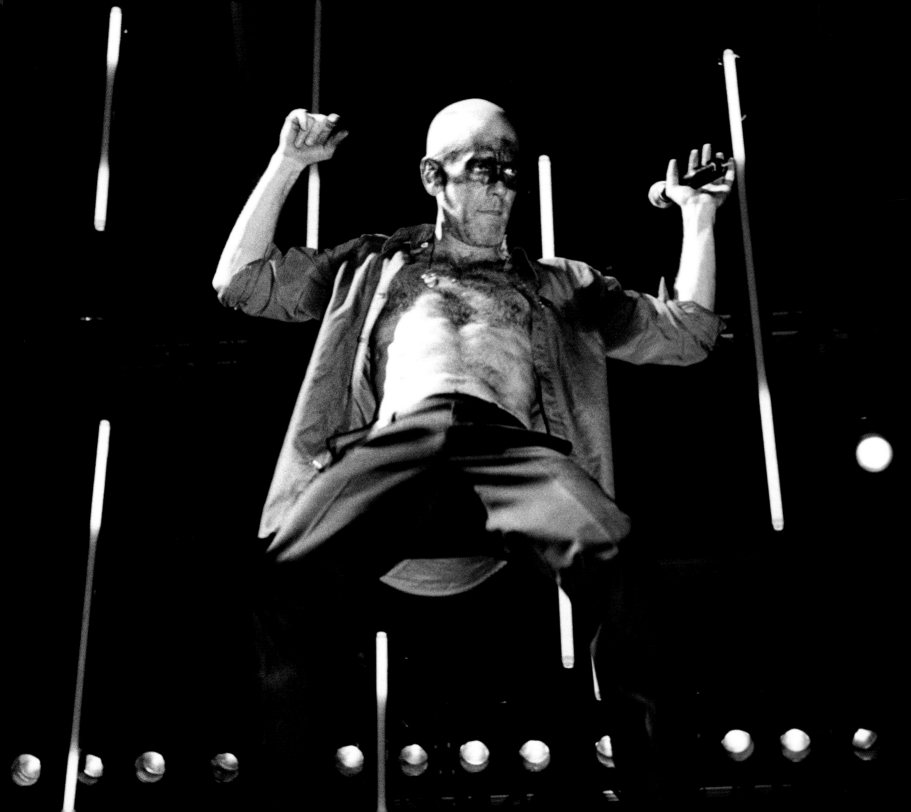

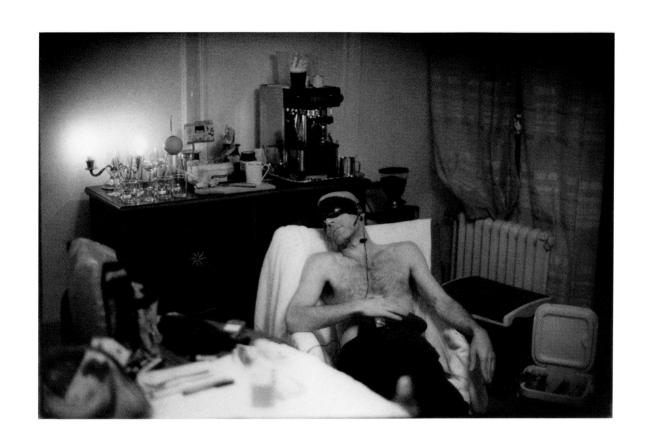

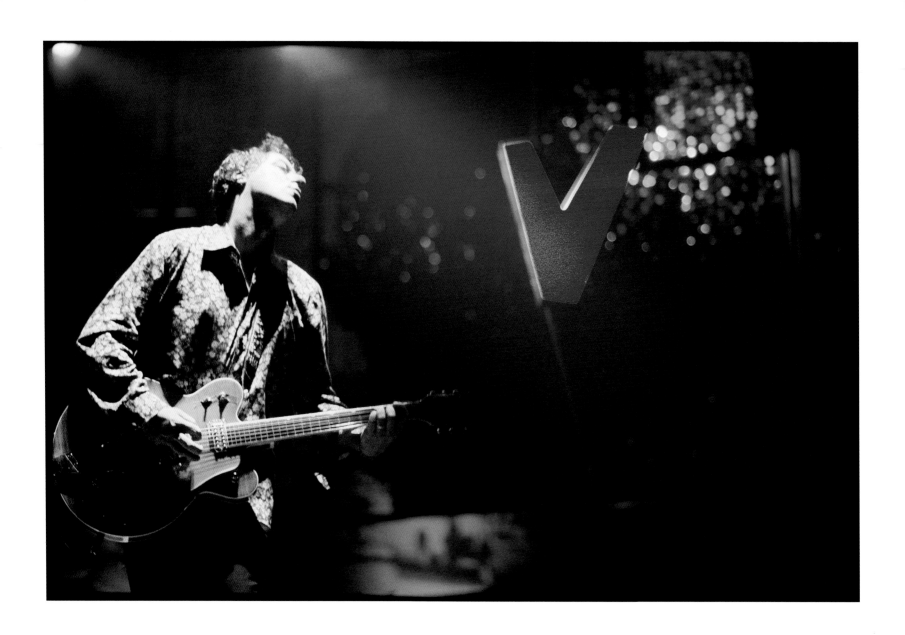

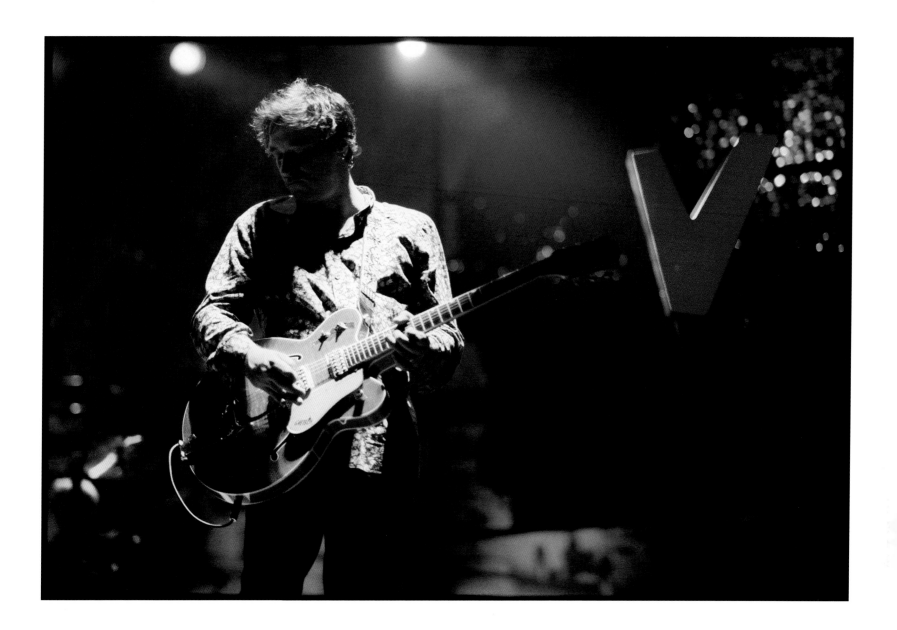

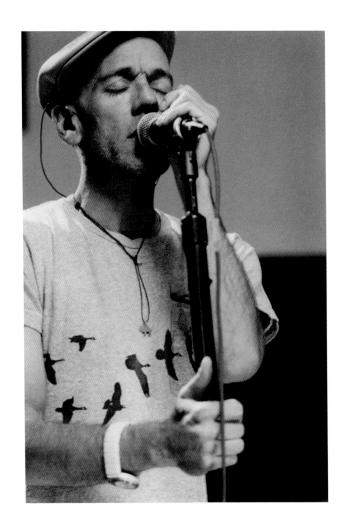
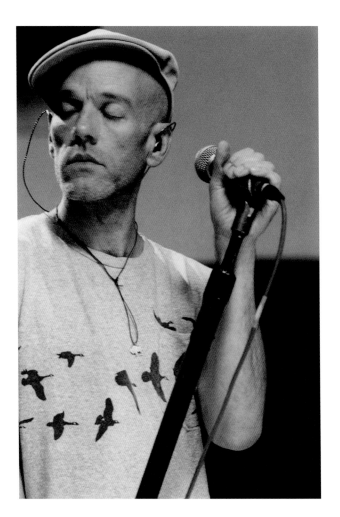

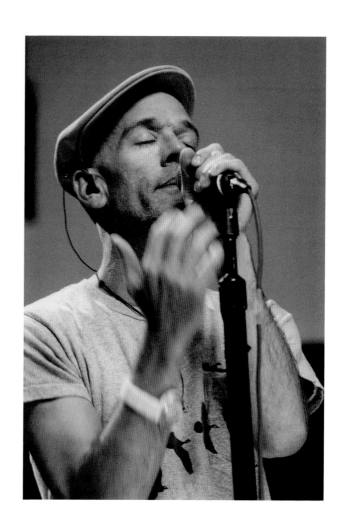

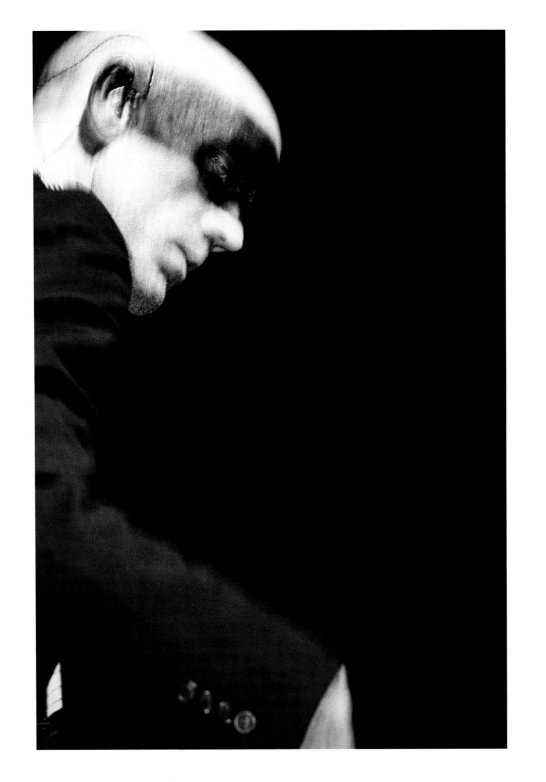

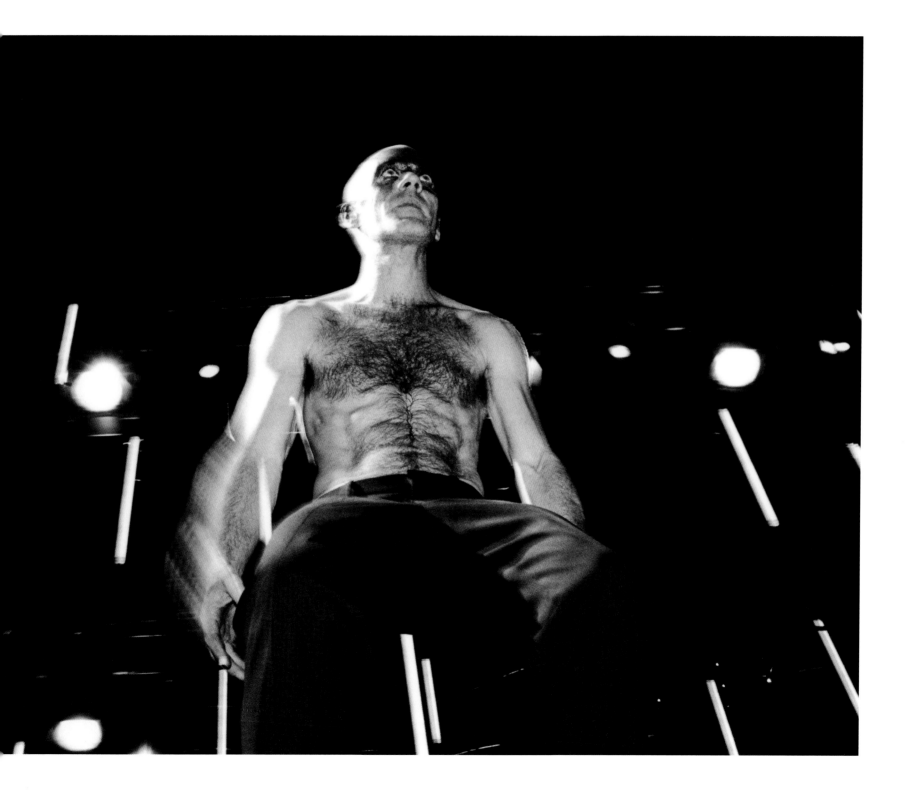

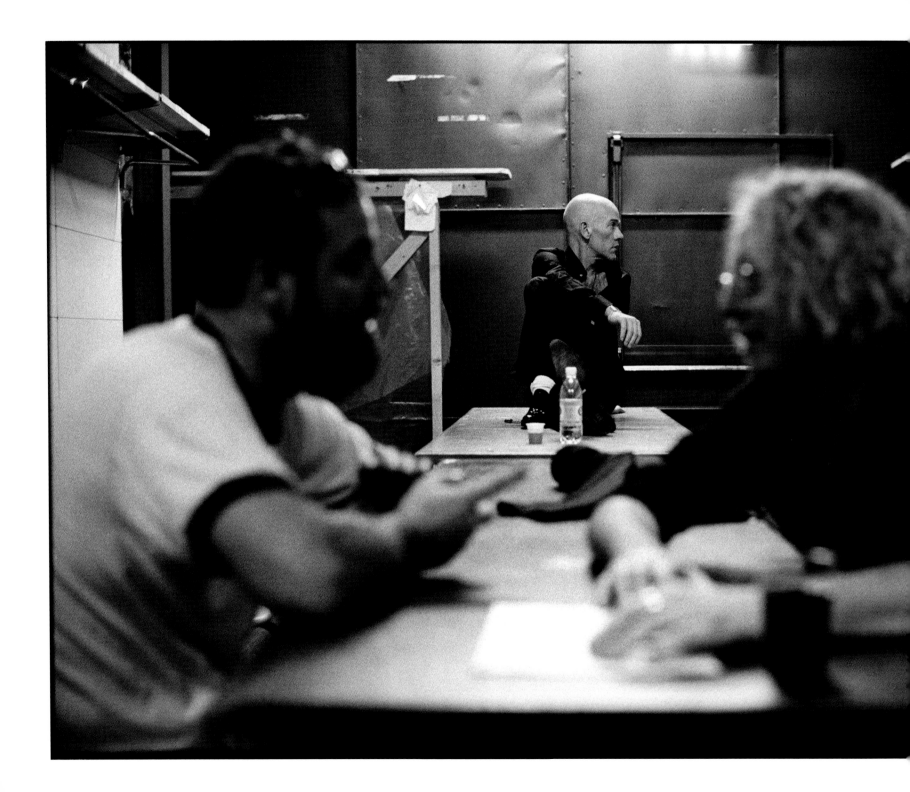

DEWITT, MIKE AND I
BACKSTAGE IN ITALY
AT A CENTURIES OLD VENUE

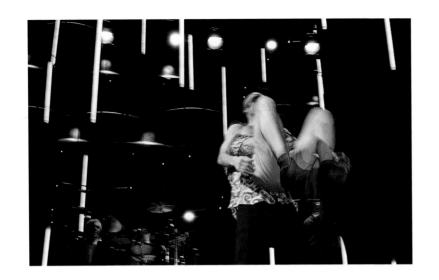
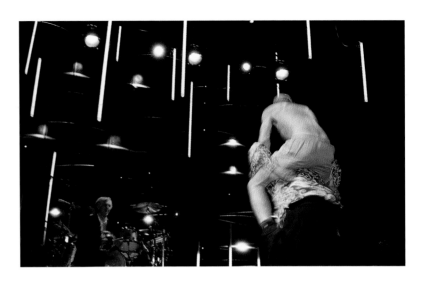
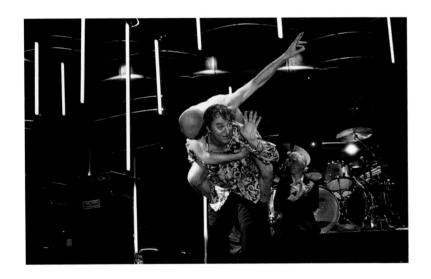
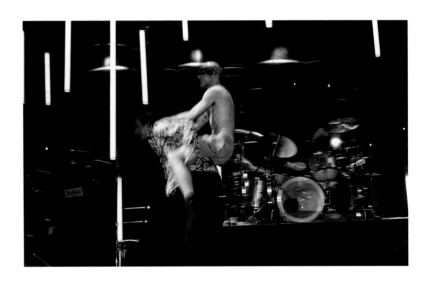

LAST SONG AT THE
(AS) SHOW OK THE TOUR

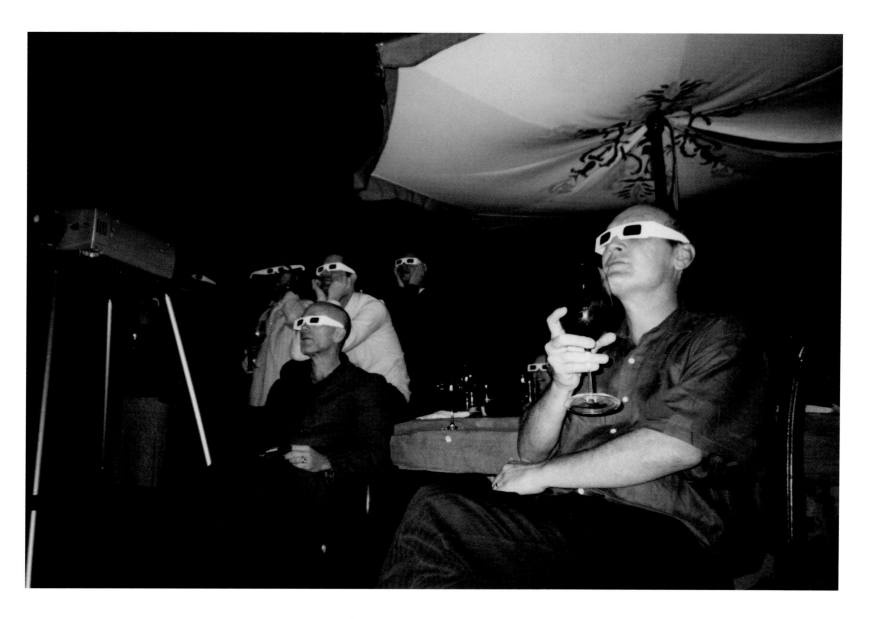

BERT'S 3-D PRESENTATION

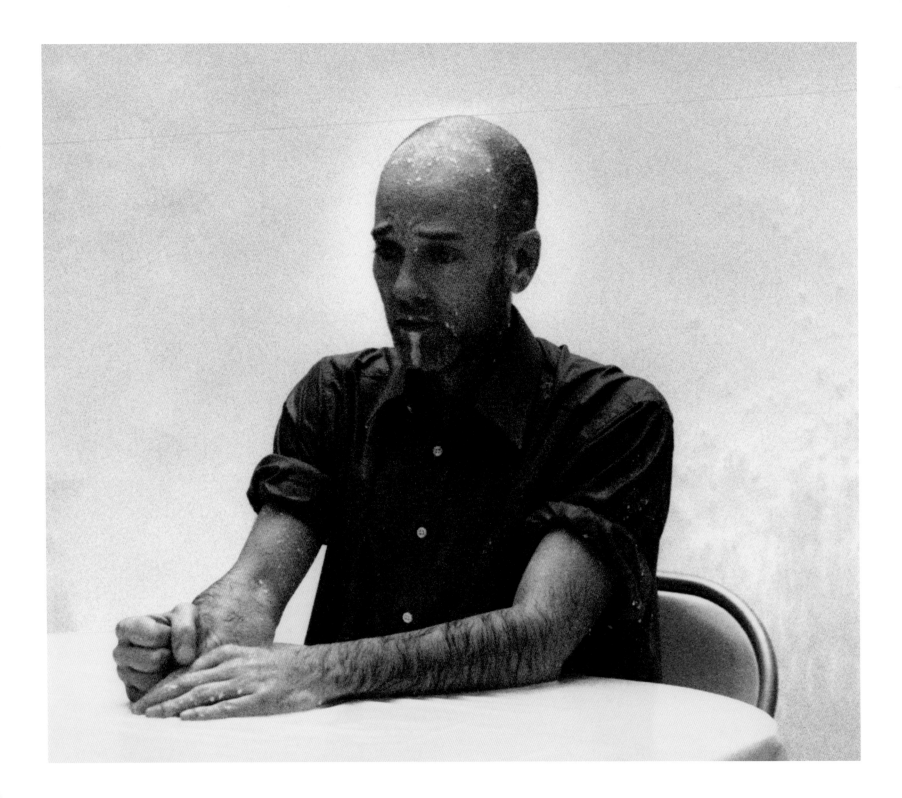

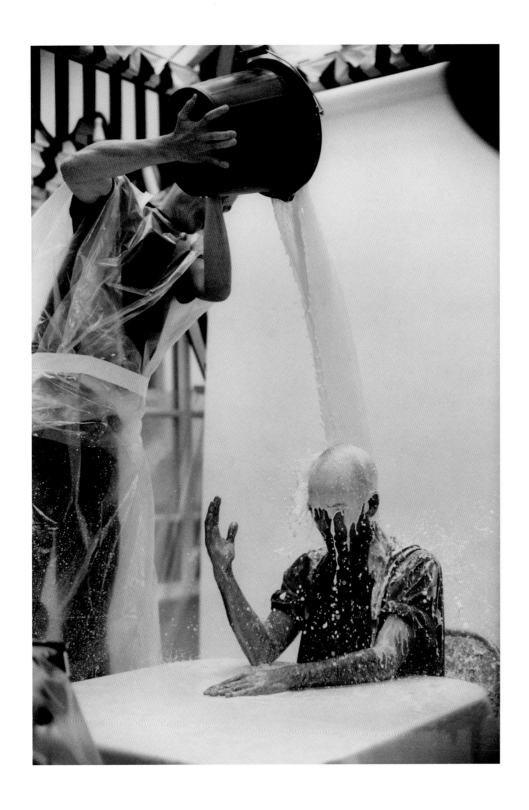

OXFAM AD CAMPAIGN
LONDON
I SMELLED LIKE
 BABY FORMULA
FOR A WEEK.

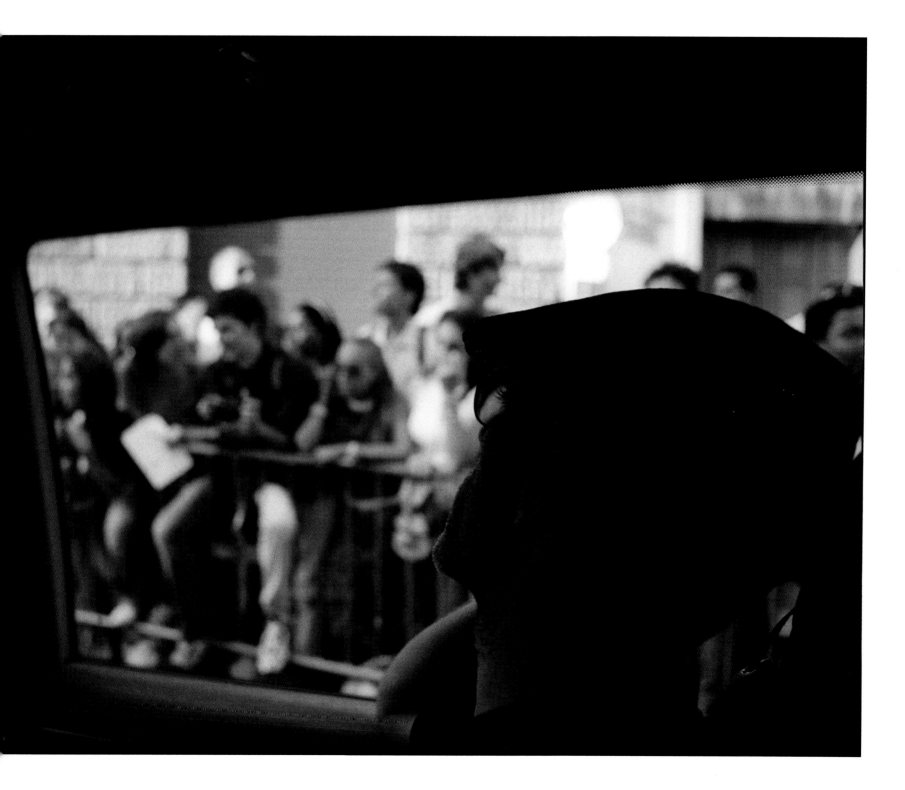

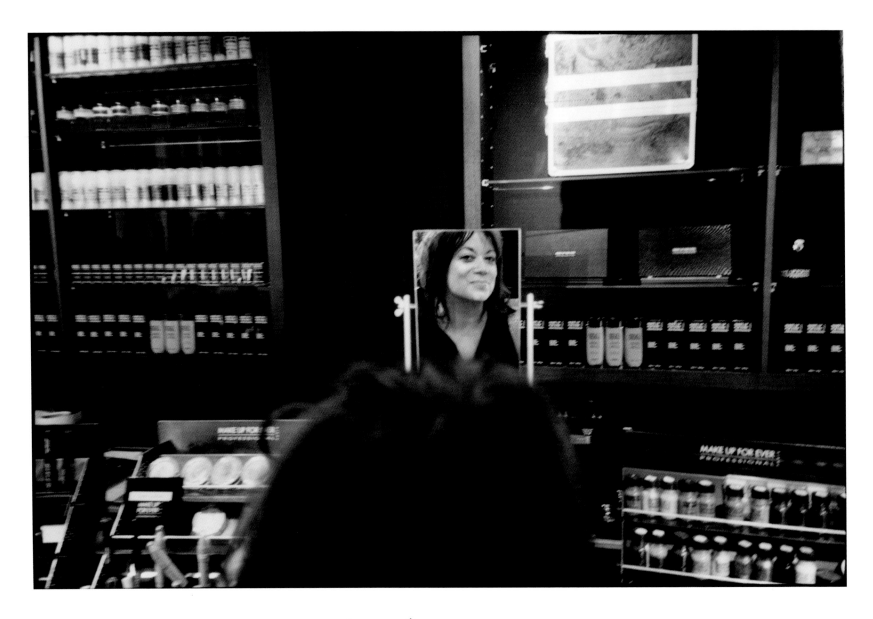

JULIE P FOREVER

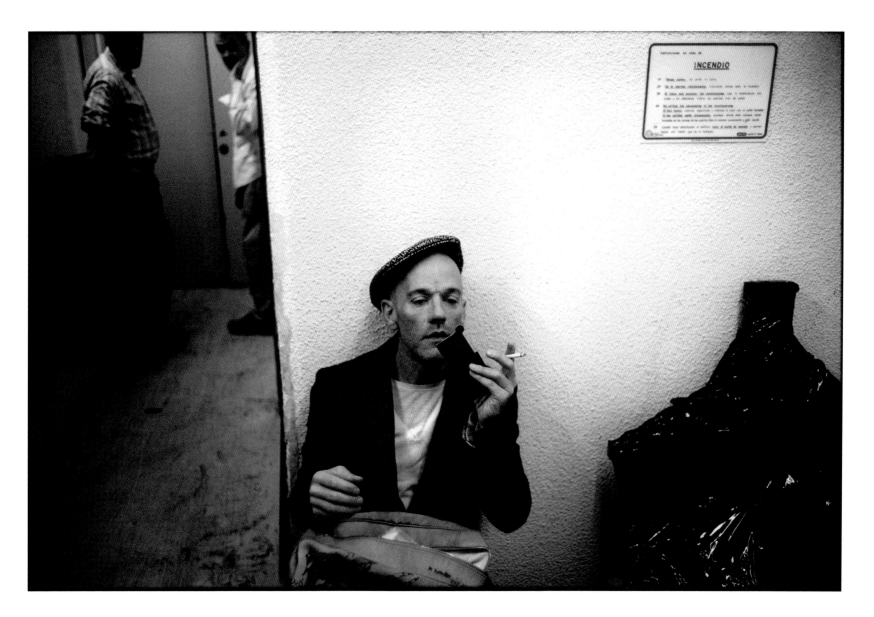

MADRID IN STORE

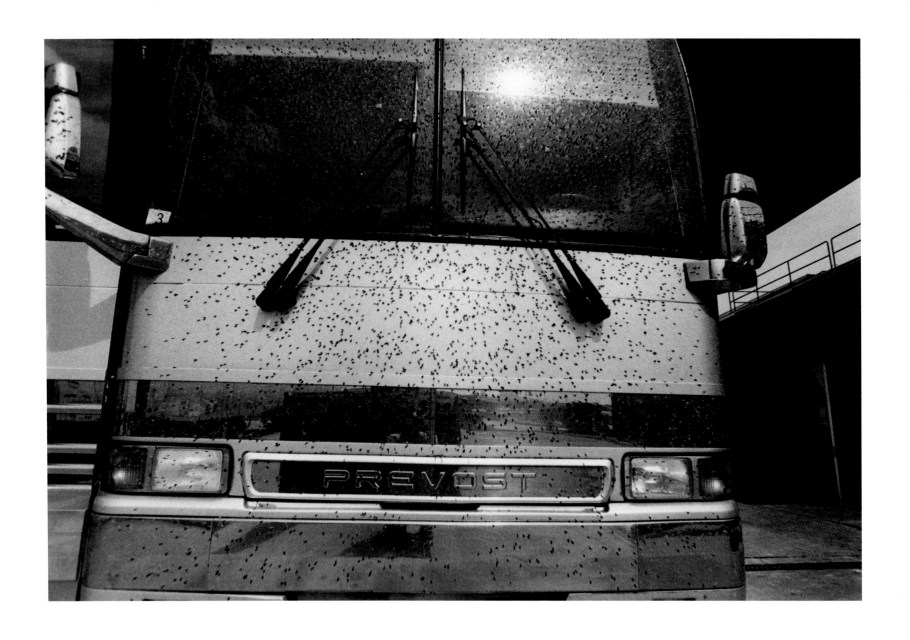

THE BUS — GLAMOROUS LIFE : DISCUSS.

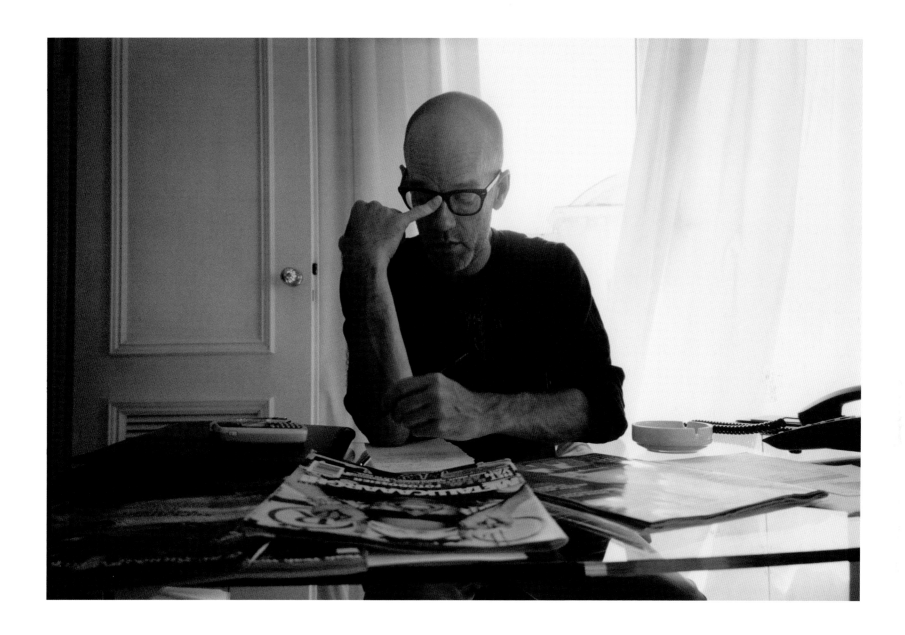

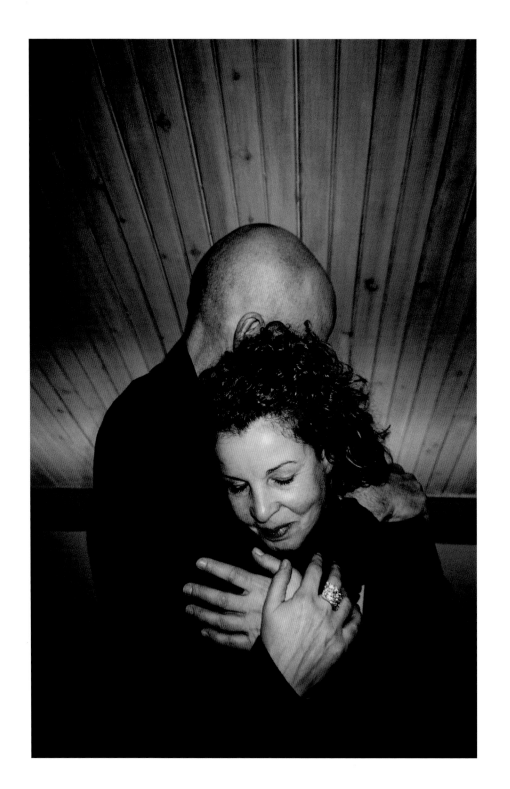

ROSIE THE
CATERERS
LAST SHOW
DUBLIN

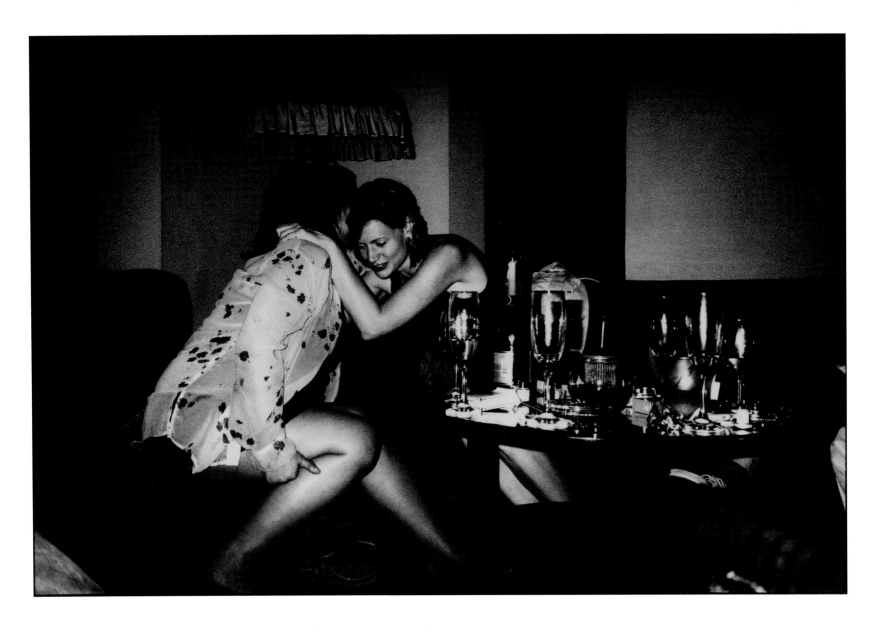

JULIE AND MEREDITH
CHATEAU MARMONT

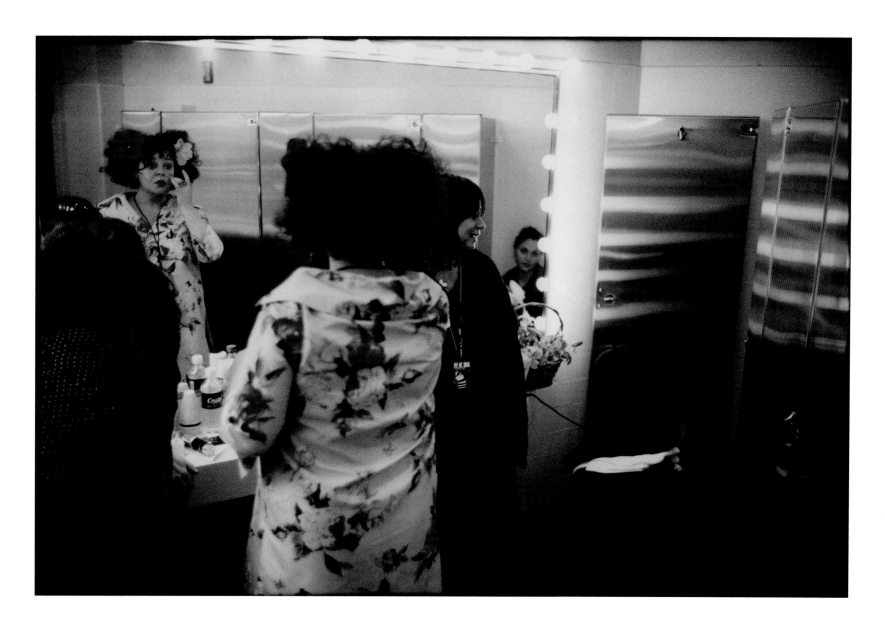

ANGELA McCLUSKEY JULIE PANEBIANCO
AND RAIN PHOENIX BACKSTAGE 2004

IN DENVER WITH WOODY

WITH WOODY IN DENVER
AFTER PLAYING RED ROCKS
~~WITH WOODS IN DENVER~~

A CRAZED NIGHT, HE AND I WERE
FIRST ON THE SCENE OF AN ACCIDENT
AND KEPT THESE TWO GUYS ALIVE
UNTIL THE AMBULANCE CAME.

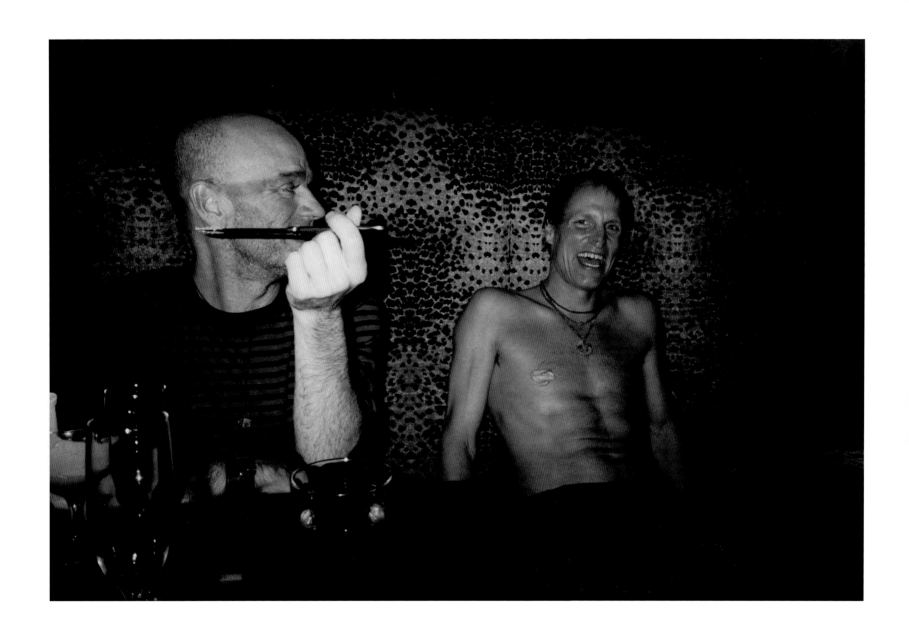

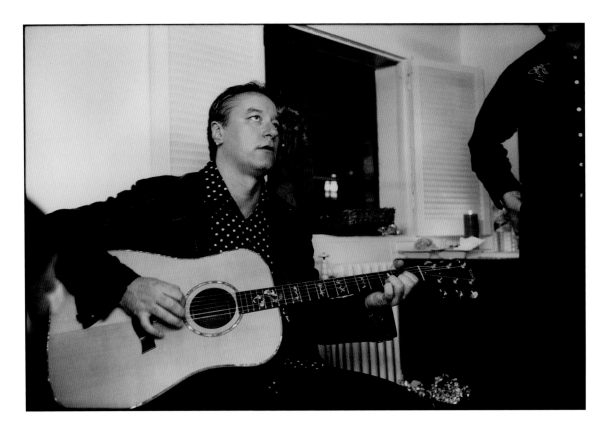

HAMMERSMITH
APOLLO

LONDON

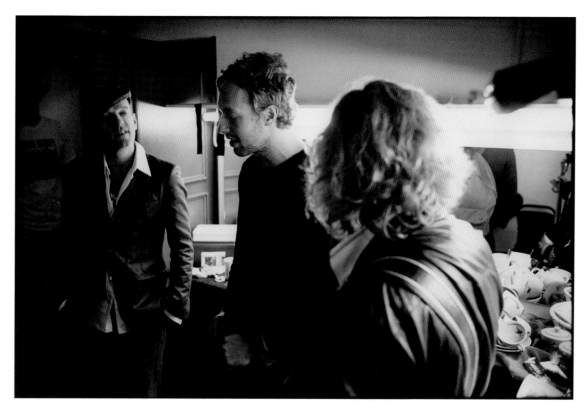

CHRIS MIKE AND I ~~SINGING~~ REHEARSING
MAN ON THE MOON BACKSTAGE

~~EDDIE~~

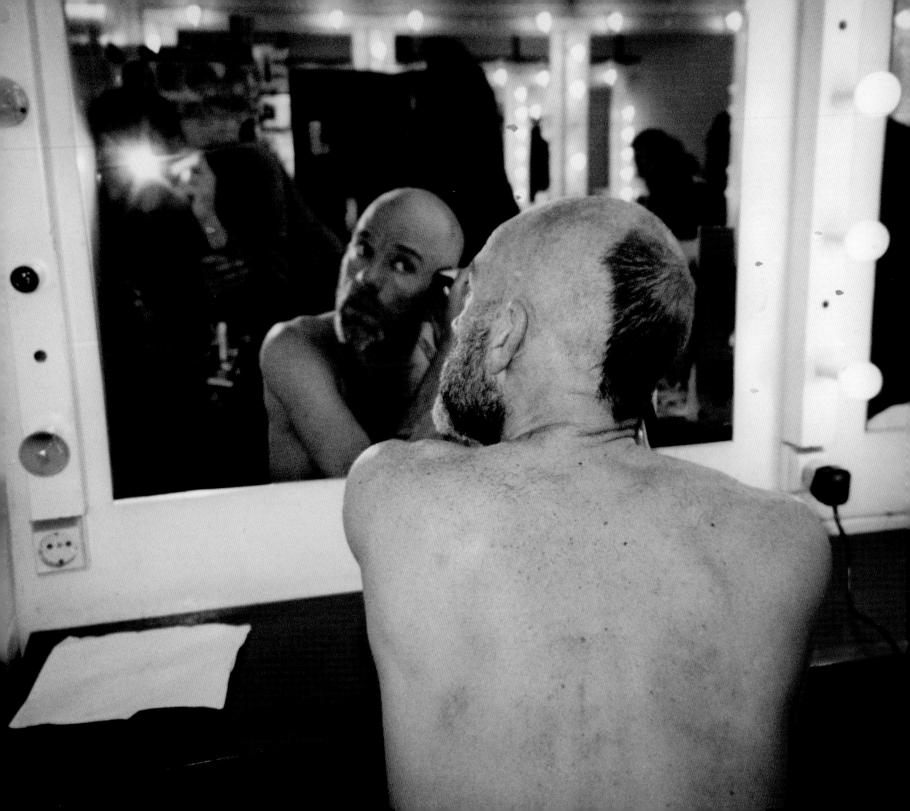

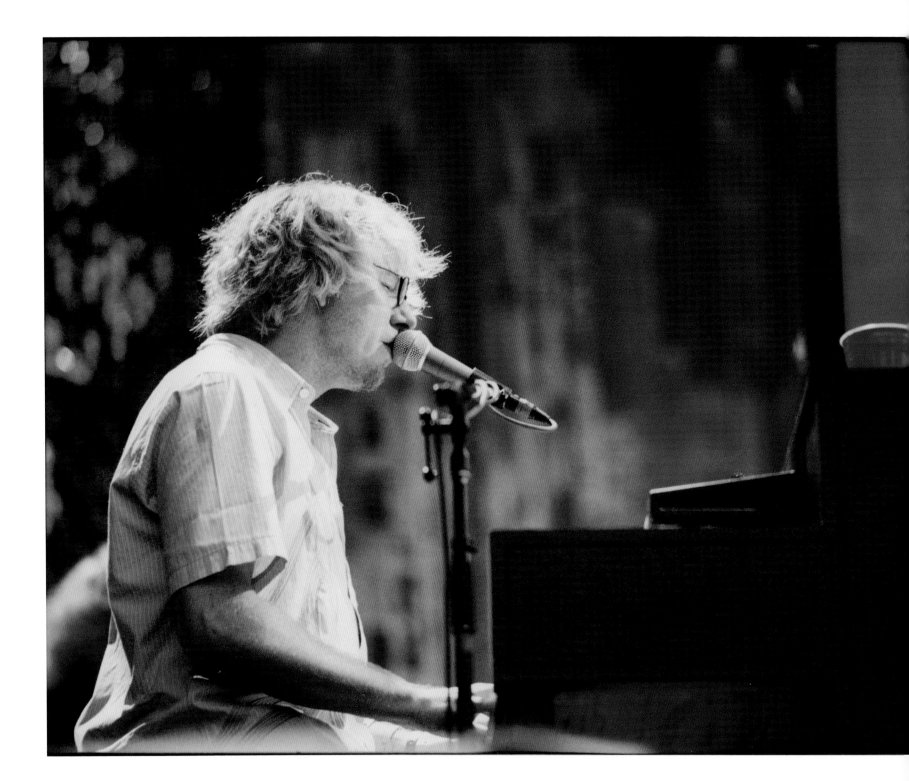

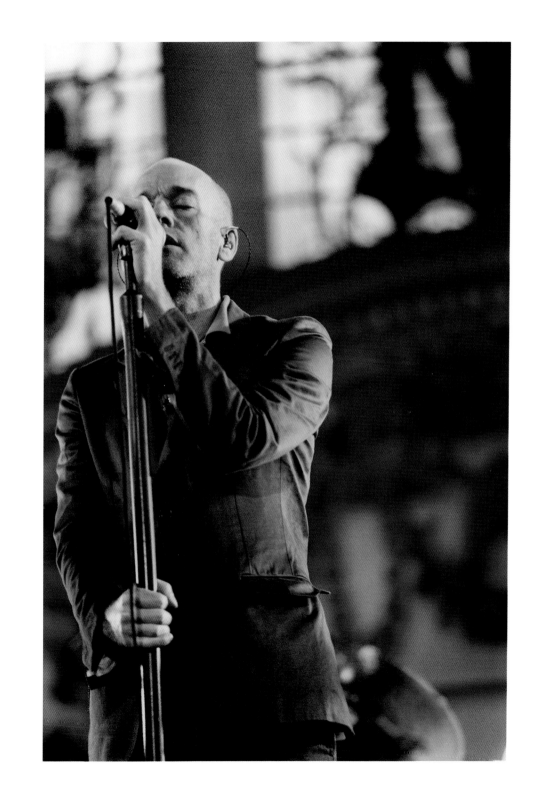

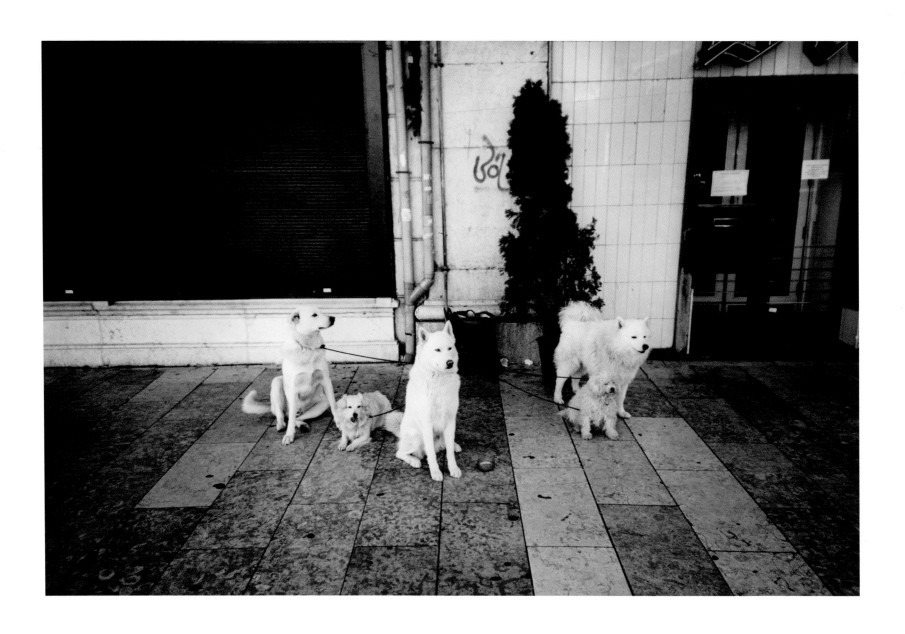

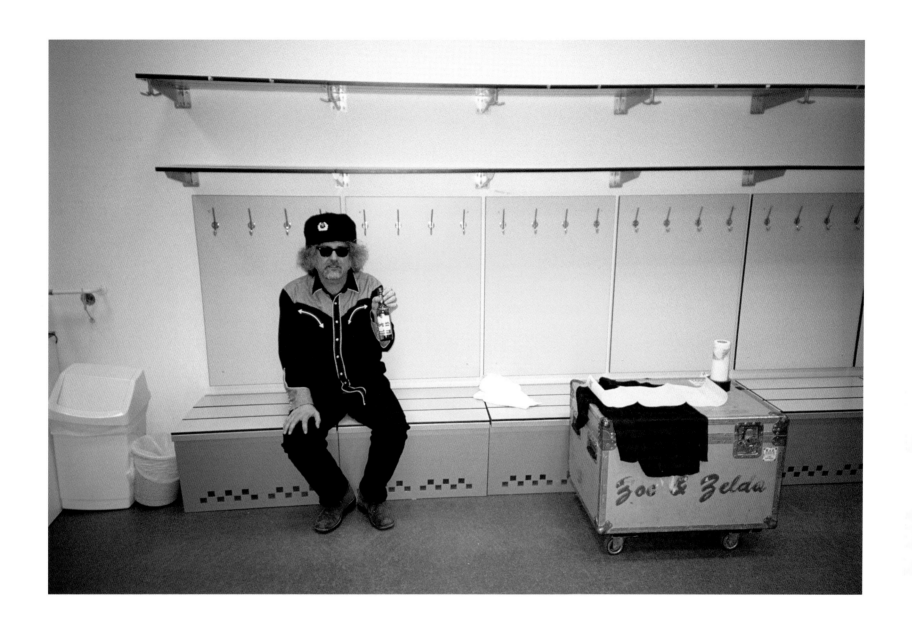

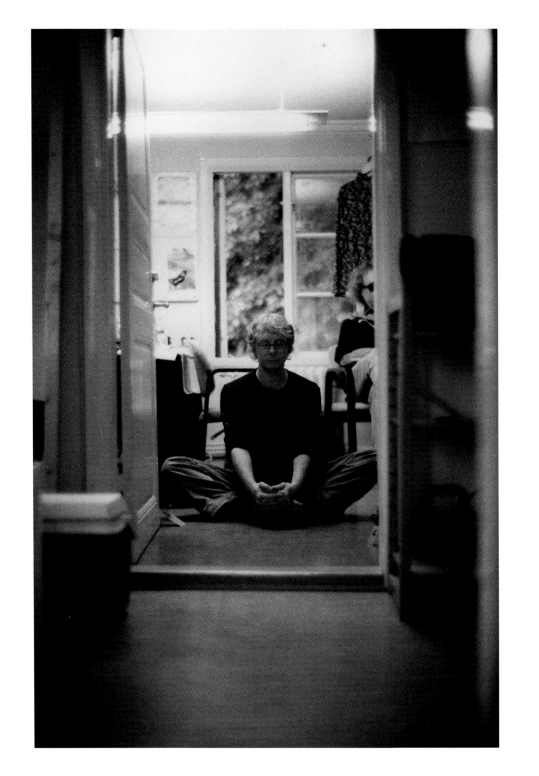

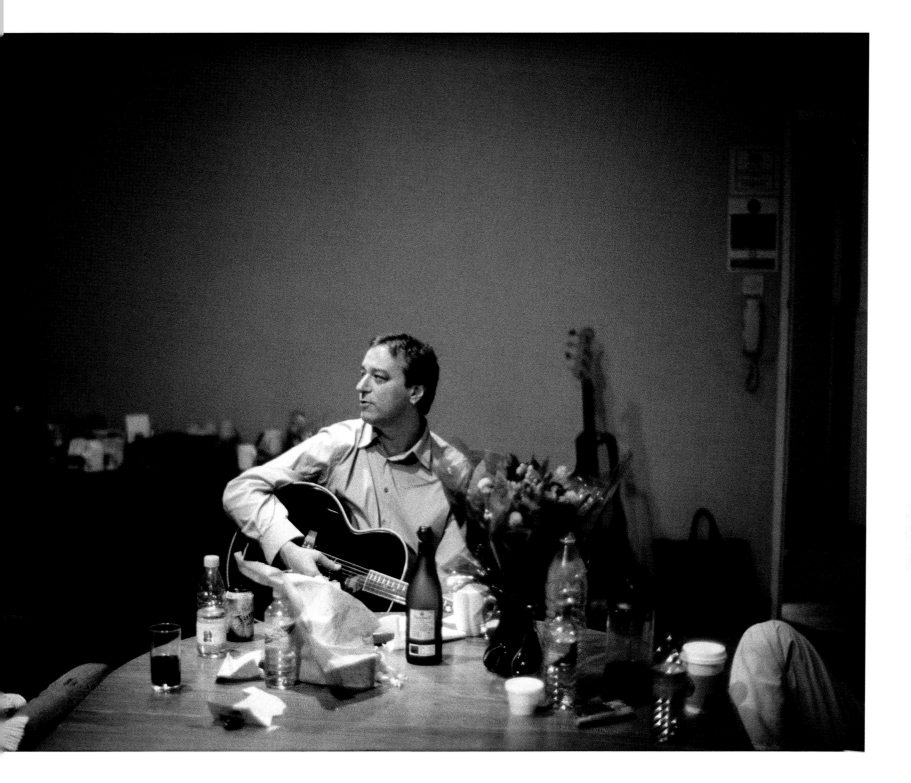

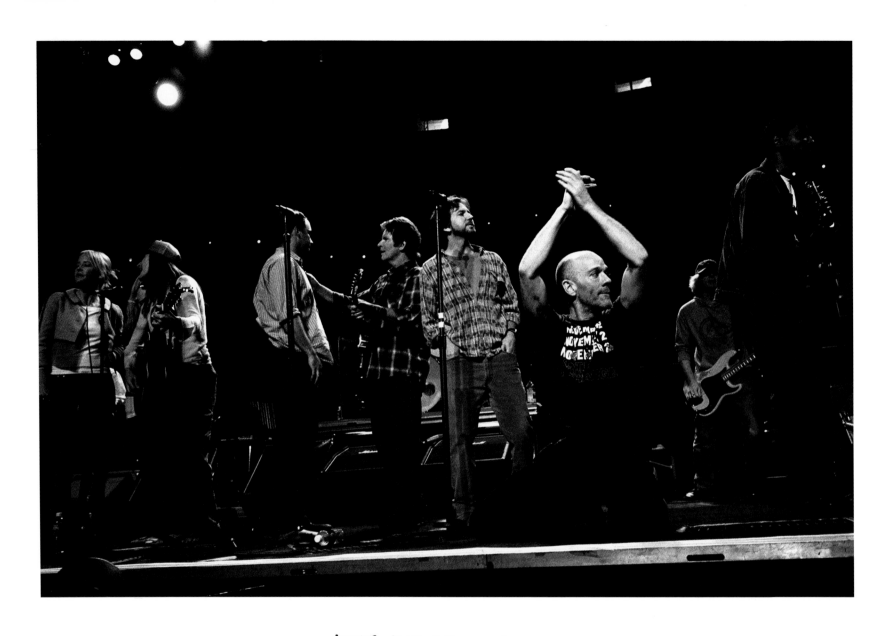

VOTE FOR CHANGE REHEARSAL;
CAMERA BLOCKING

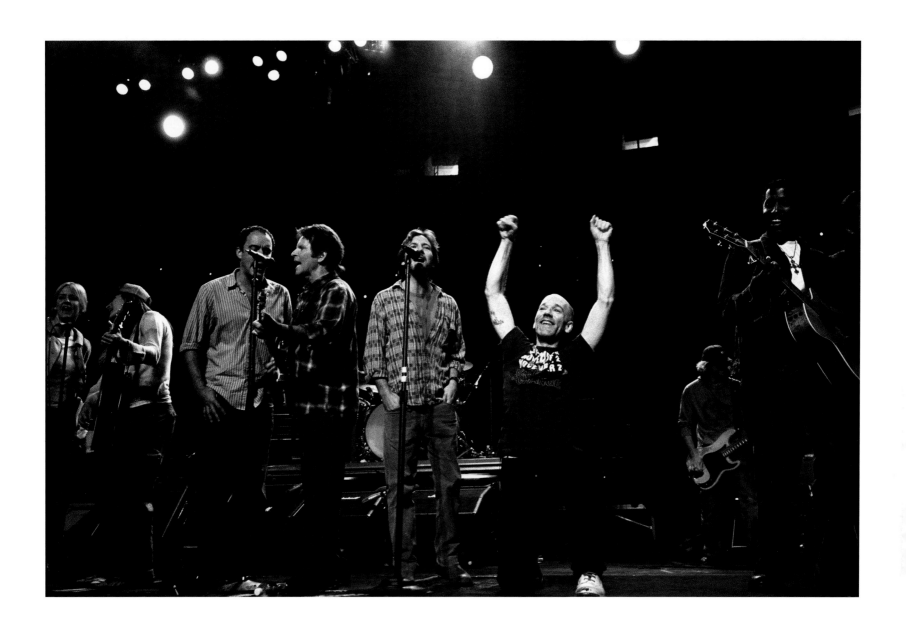

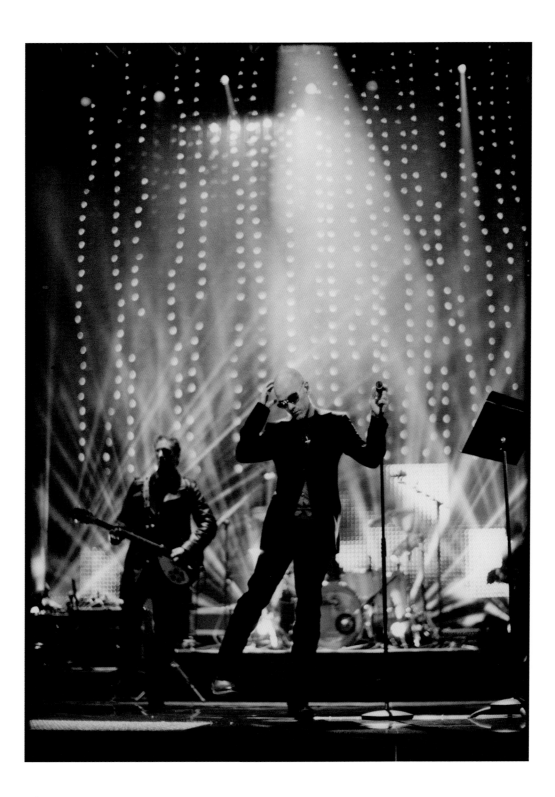

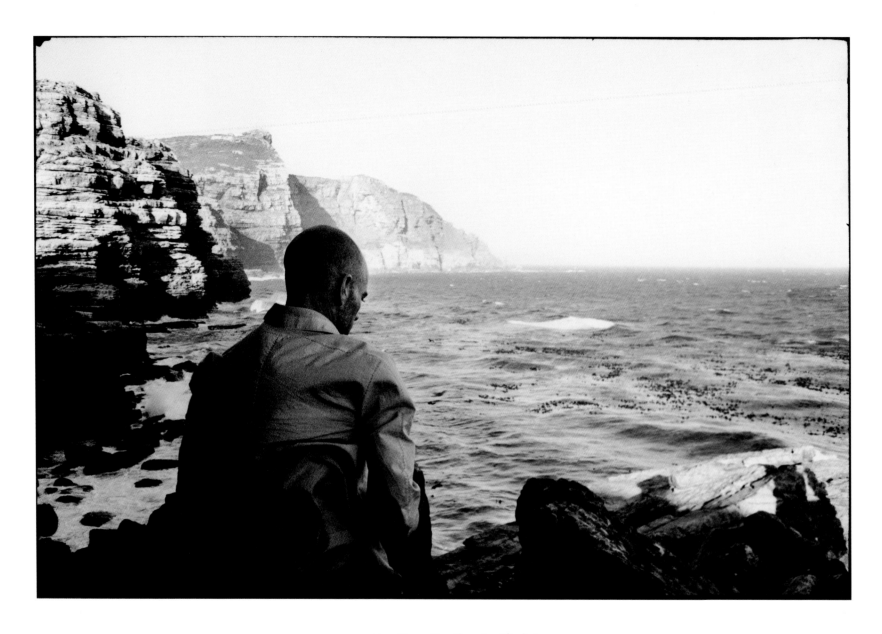

CAPE OF GOOD HOPE

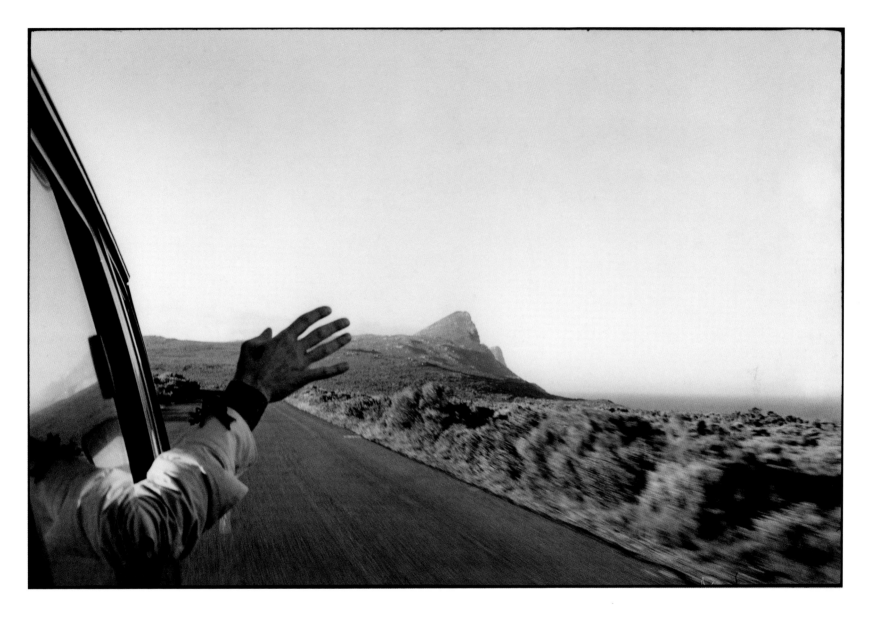

THE MOST SOUTHERN TIP OR AFRICA

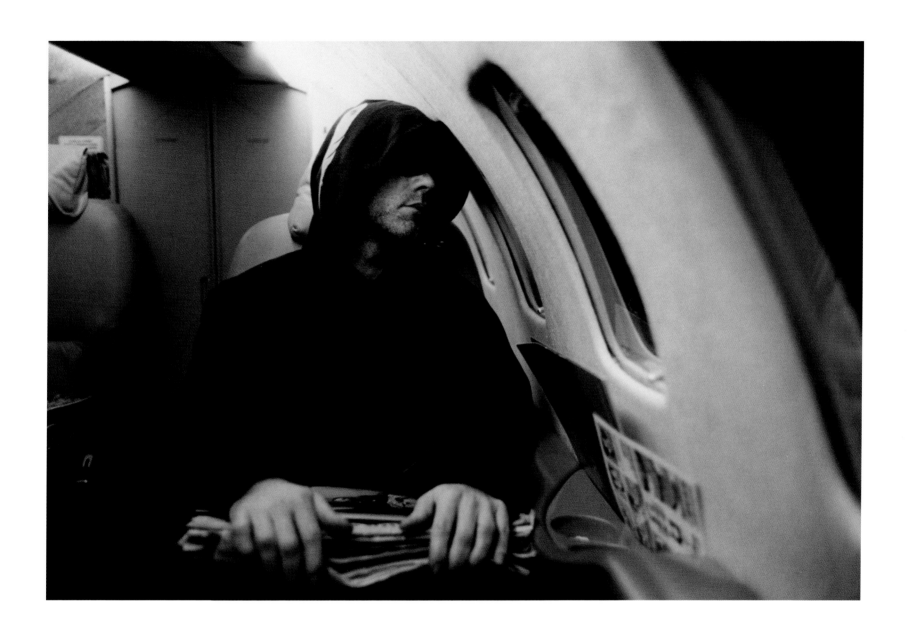

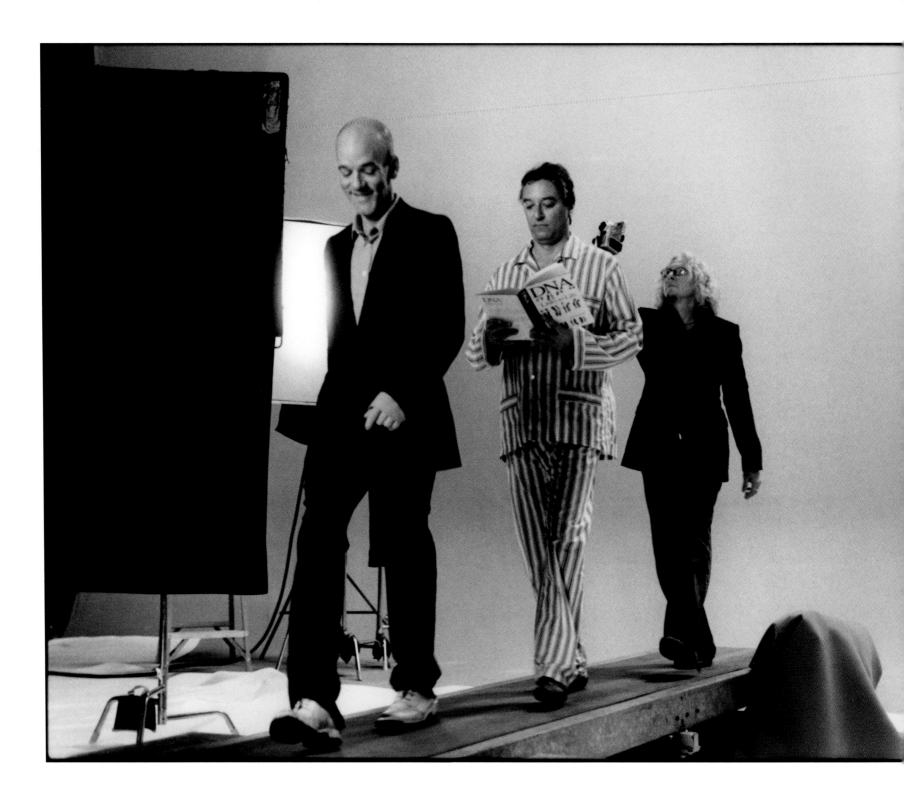

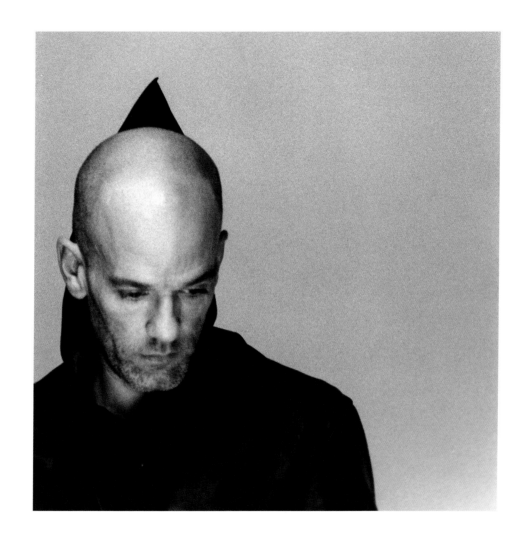

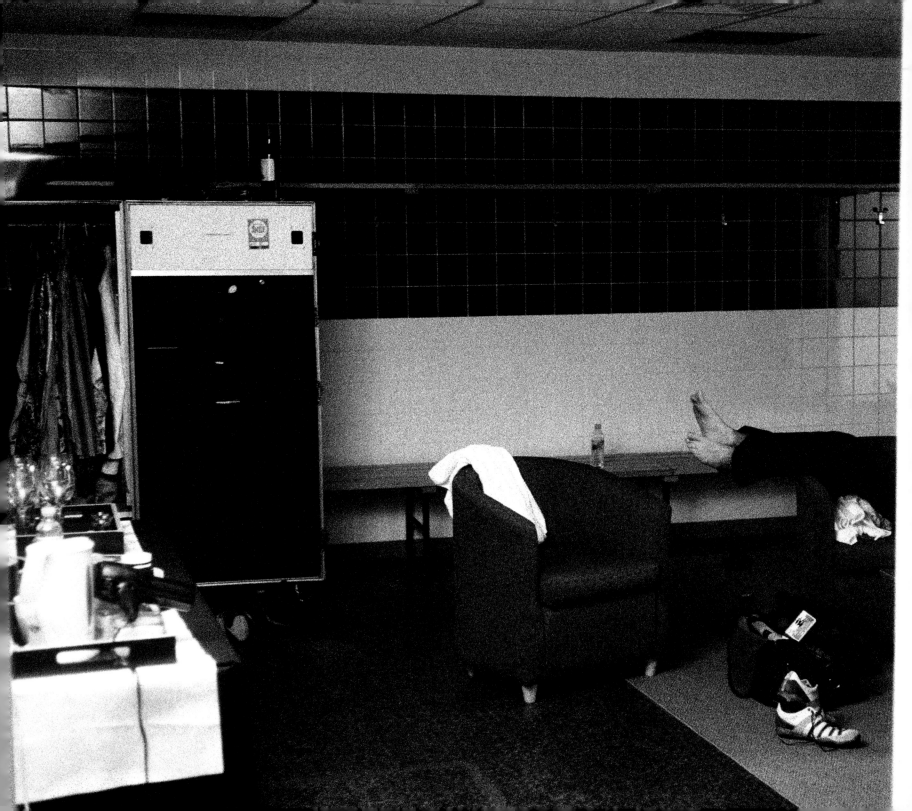

When people ask me what it's
like to go on tour to glamourous
locales....

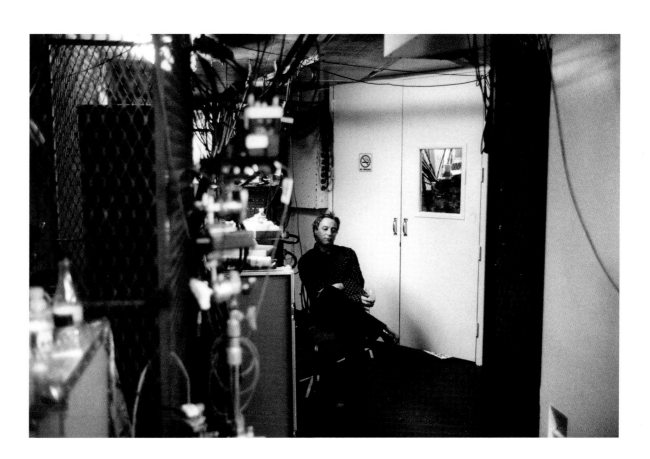

mexico city

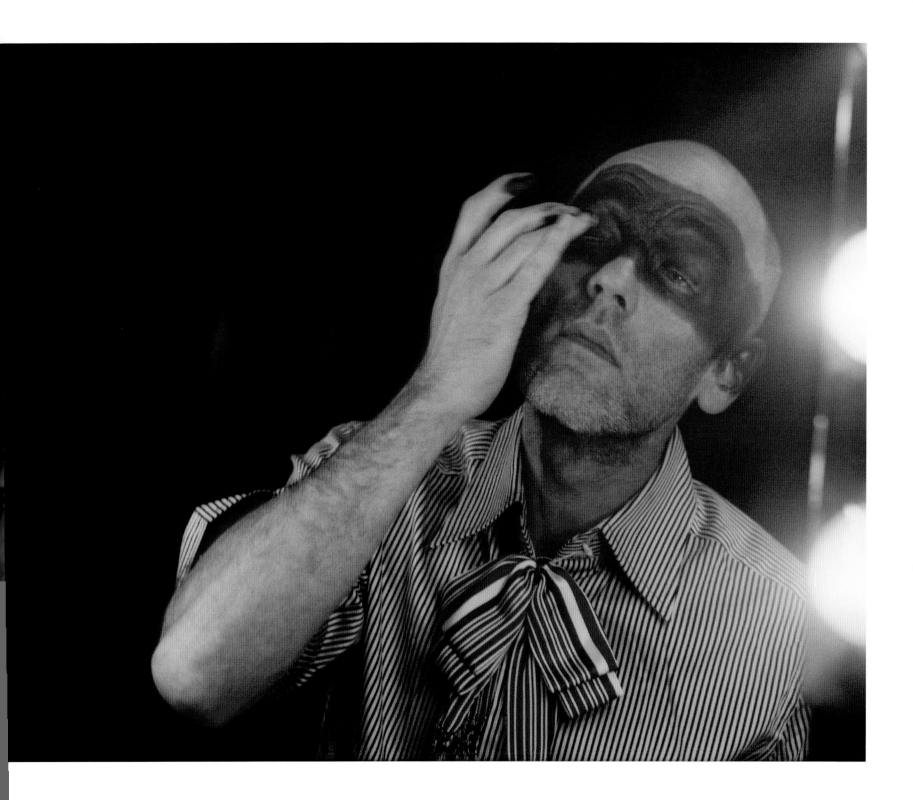

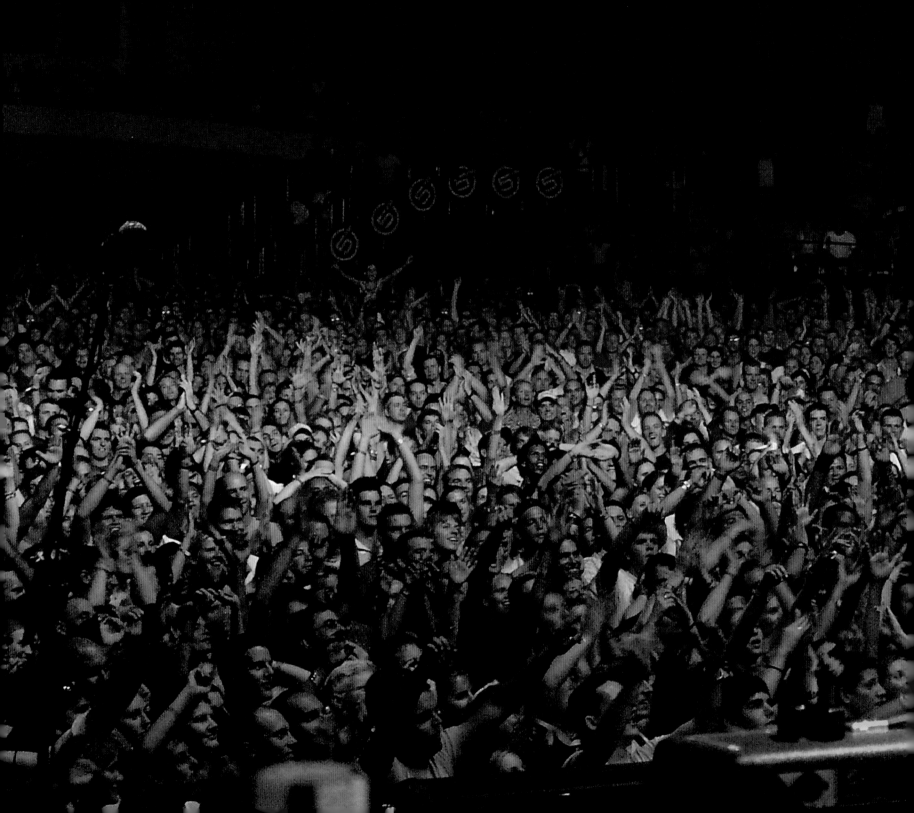

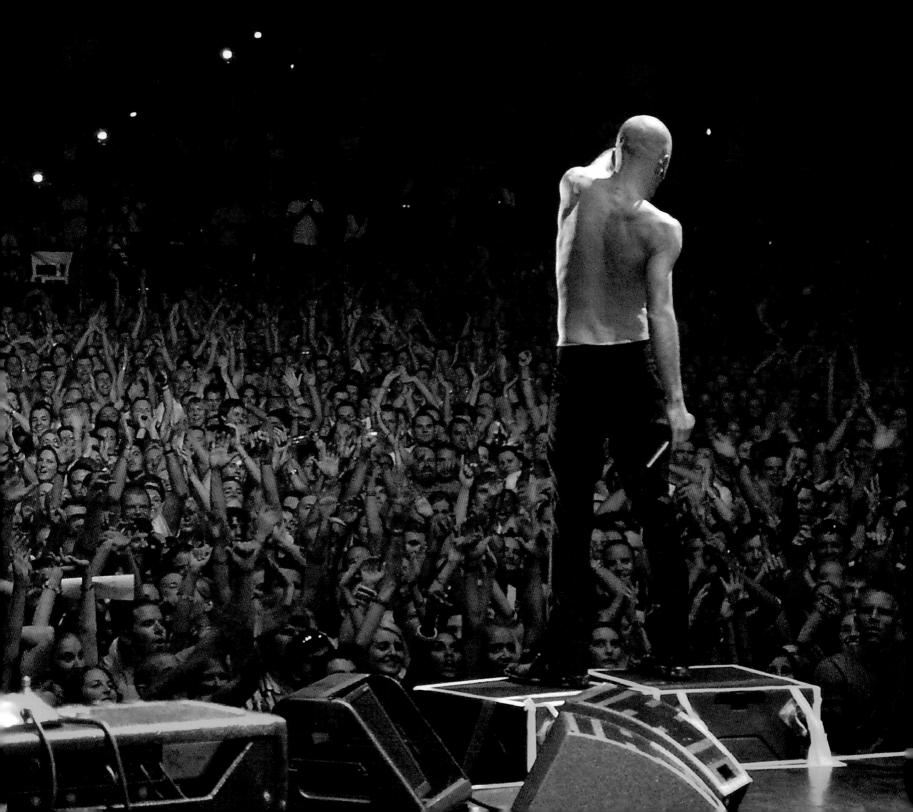

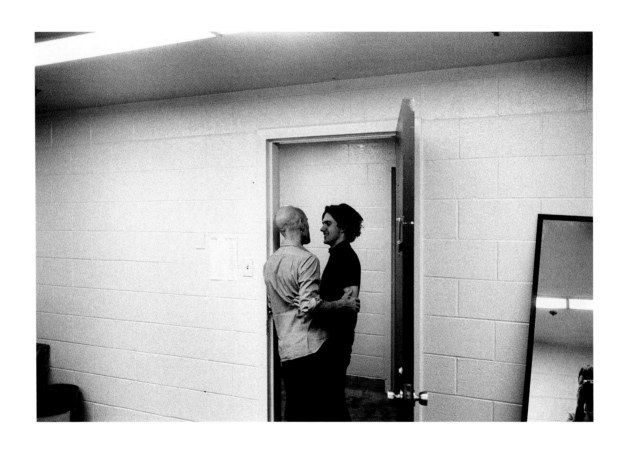

WASH DC
CONOR

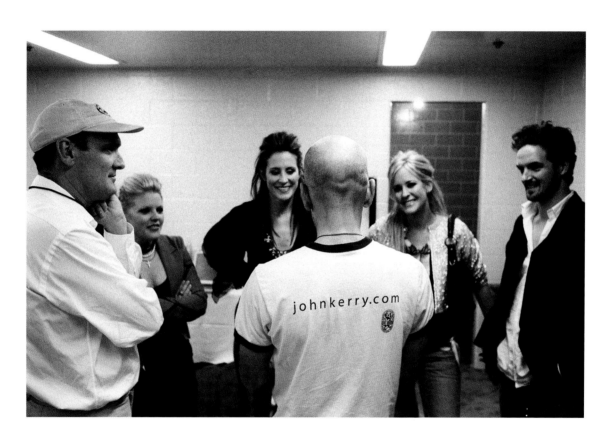

getting ready to Vote for Change

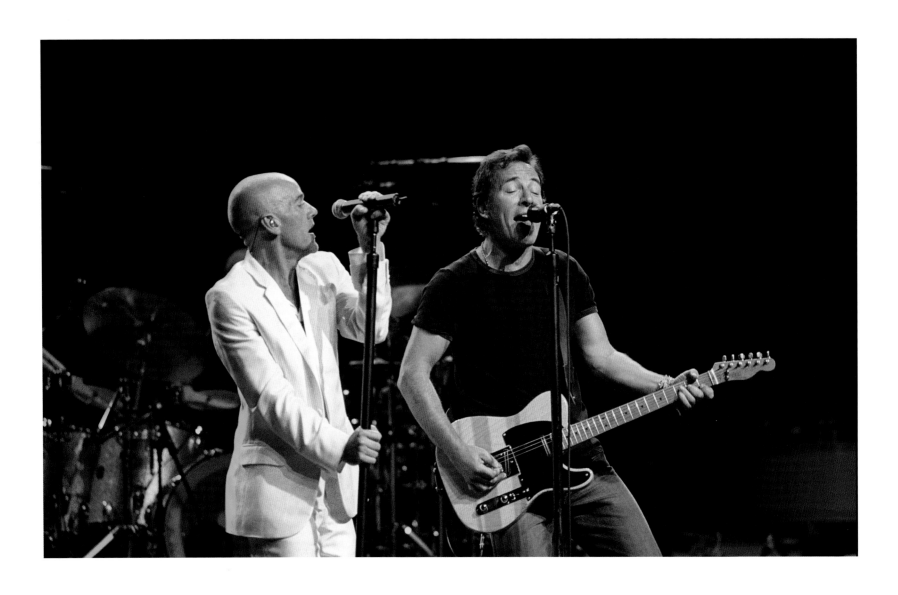

Men on the Moon

The Trilateral Commission

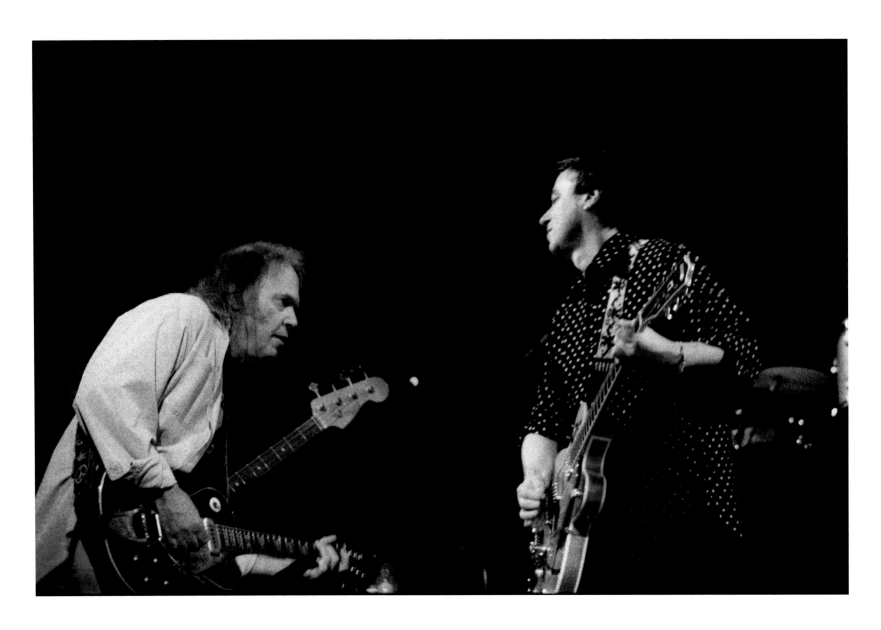

Playing with Neil is like stopping time.

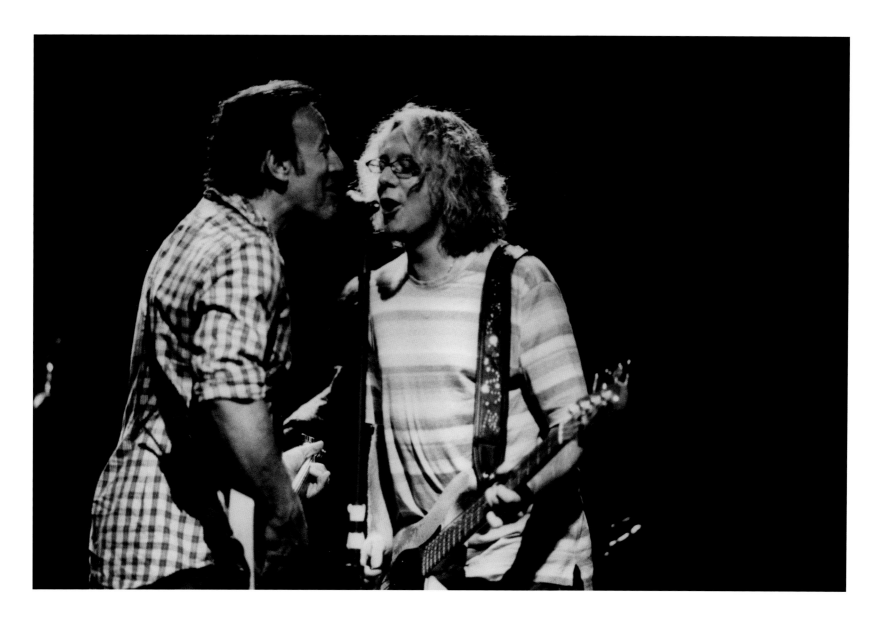

If there's a rock and roll heaven...
I've already been there.

Twinspiration

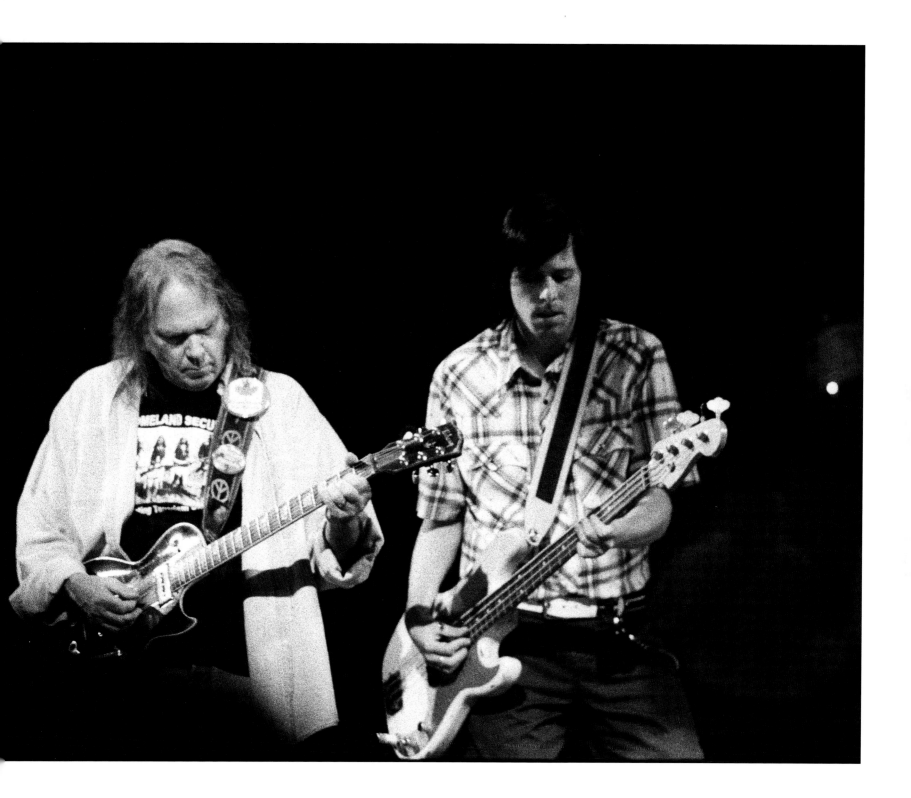

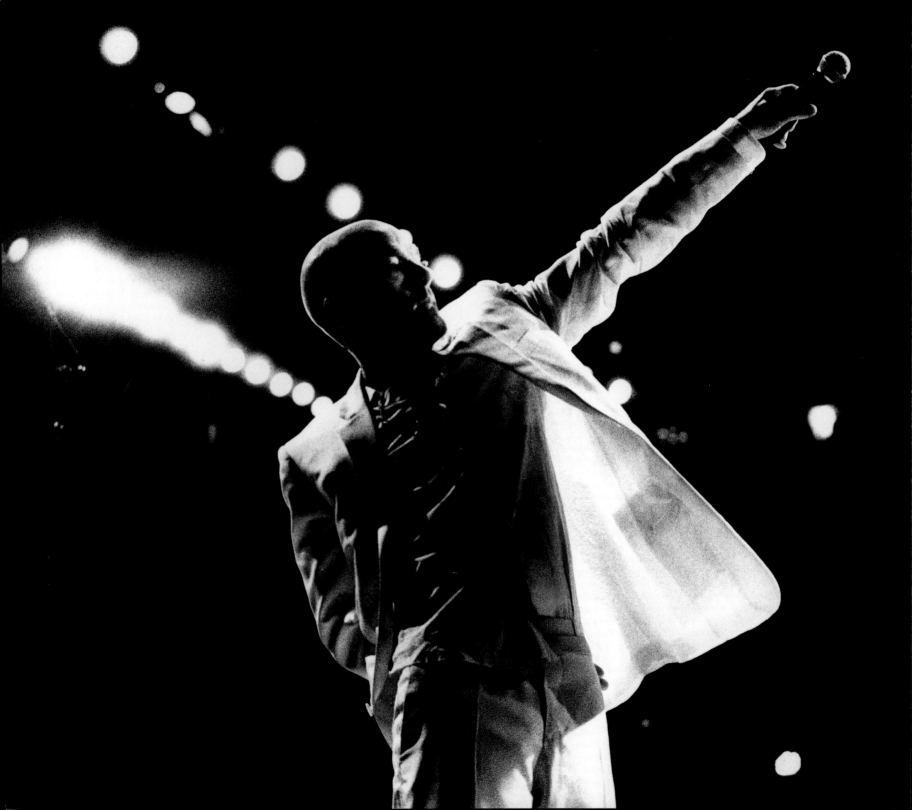

Ken: its 9.50, do you know where..?

o well

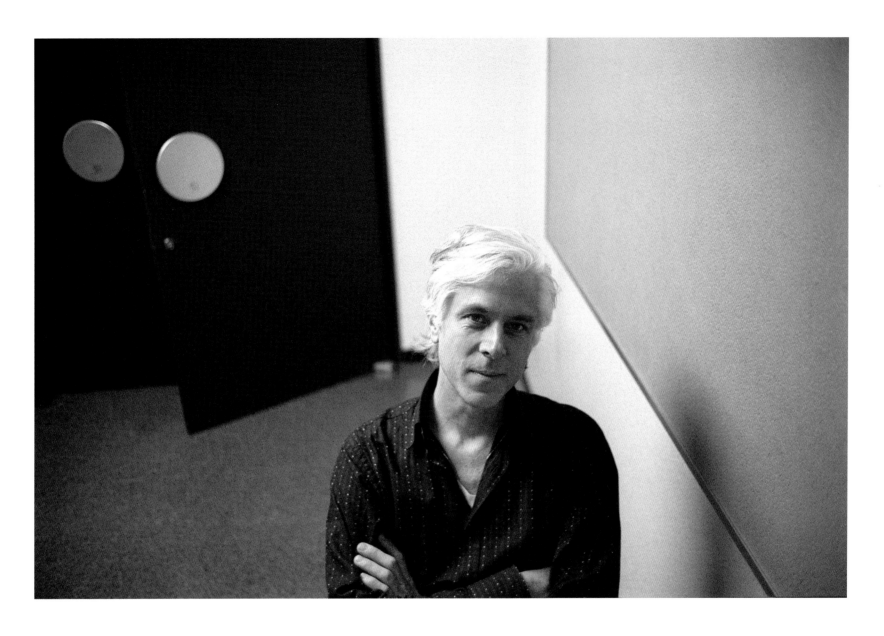

a beautiful man makes a beautiful noise

VÁNBC
WITH ANTON

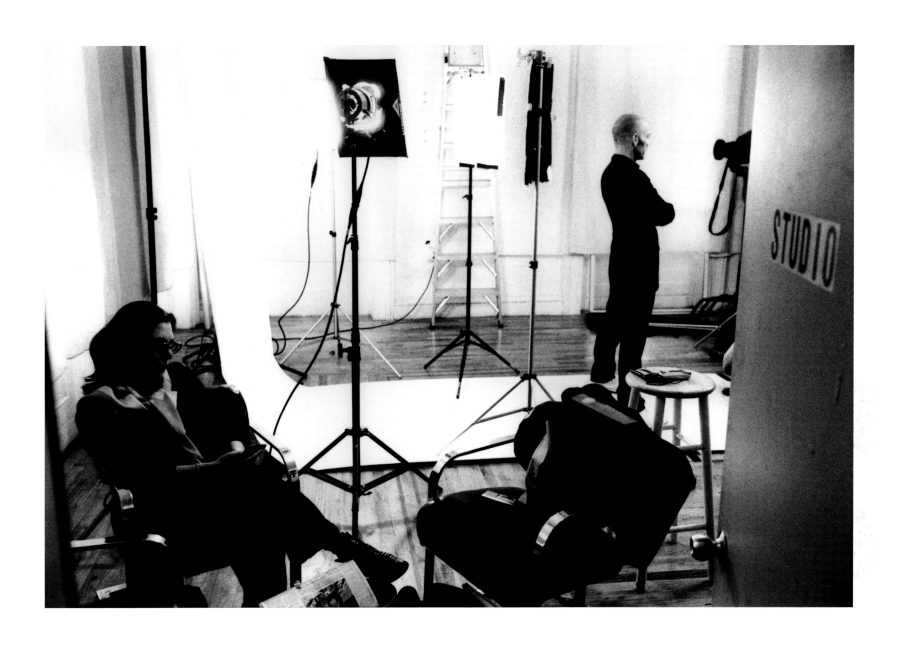

NYC
WITH LIZ

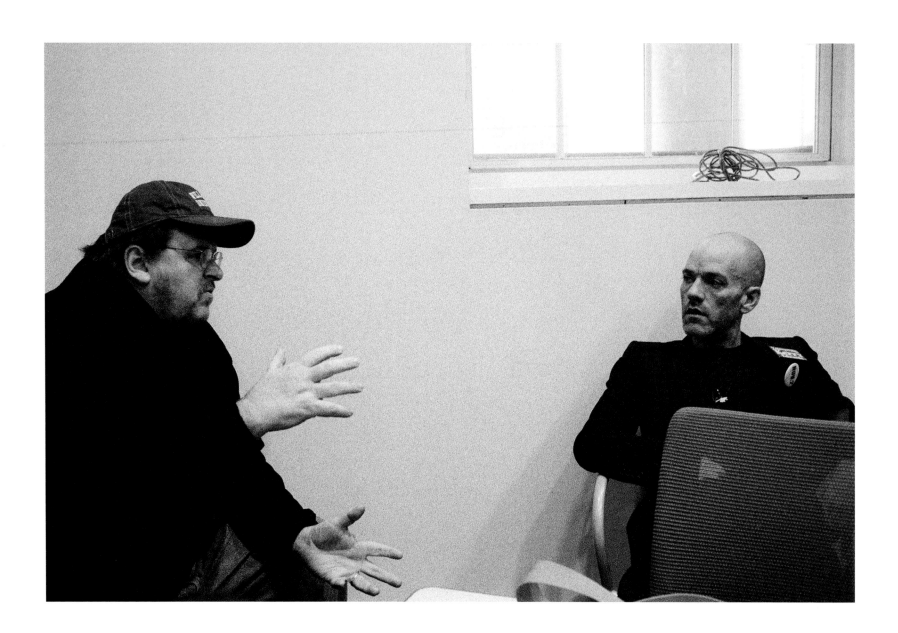

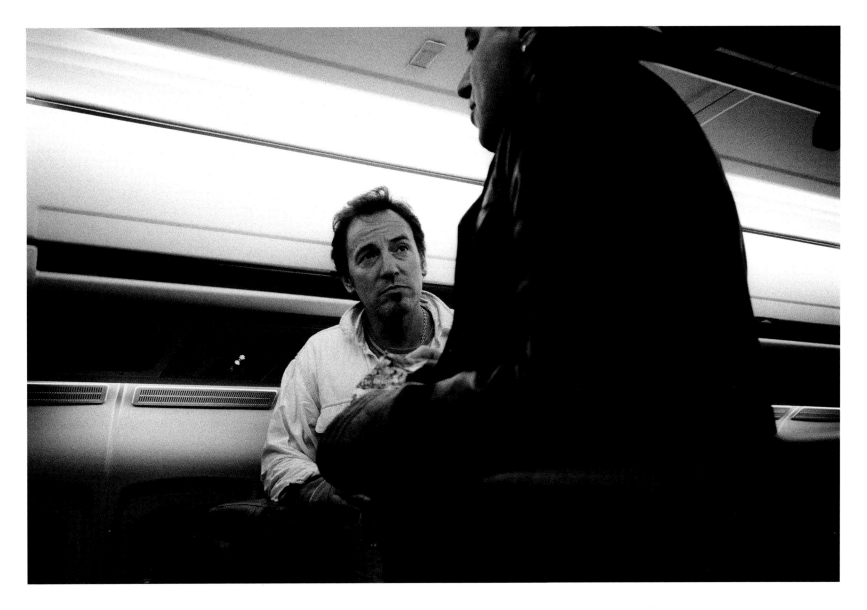

I'd like to think I'm imparting
great words of wisdom, but
the odds are against it

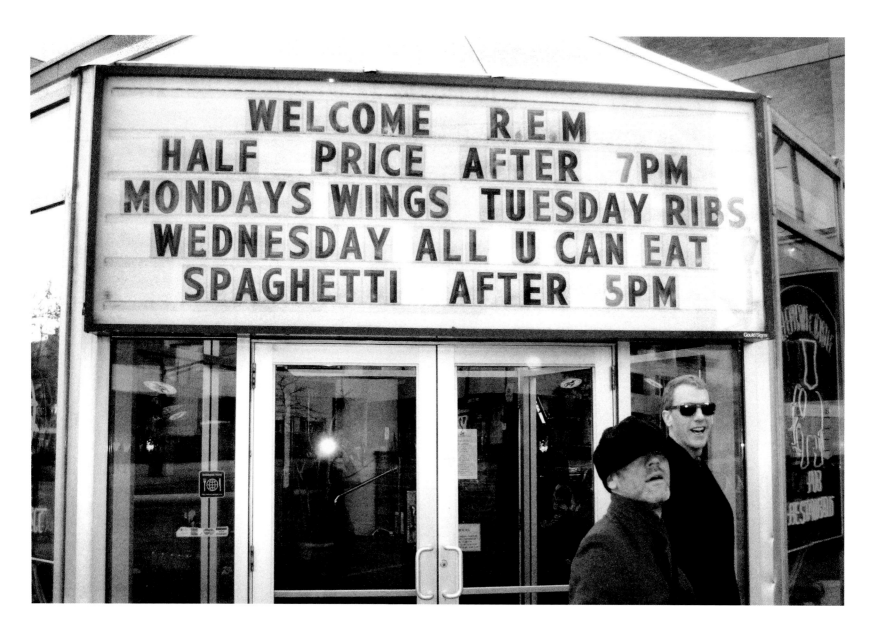

I hop were playing there
on Wednesday

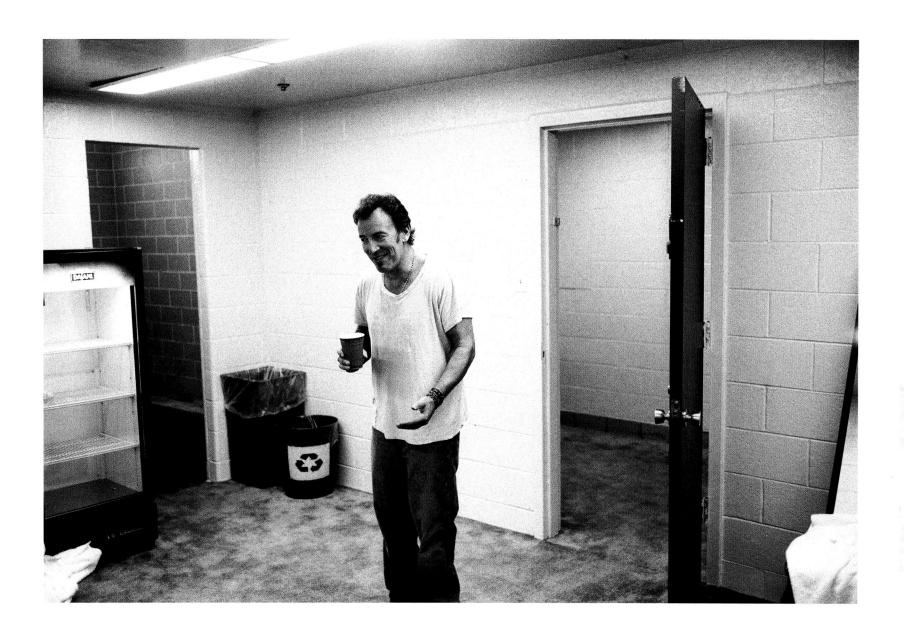

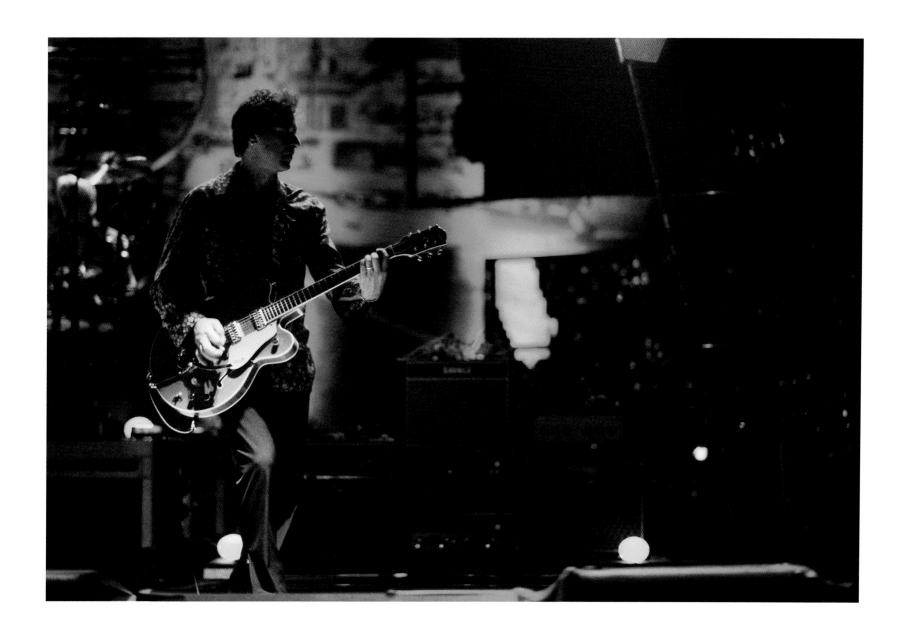

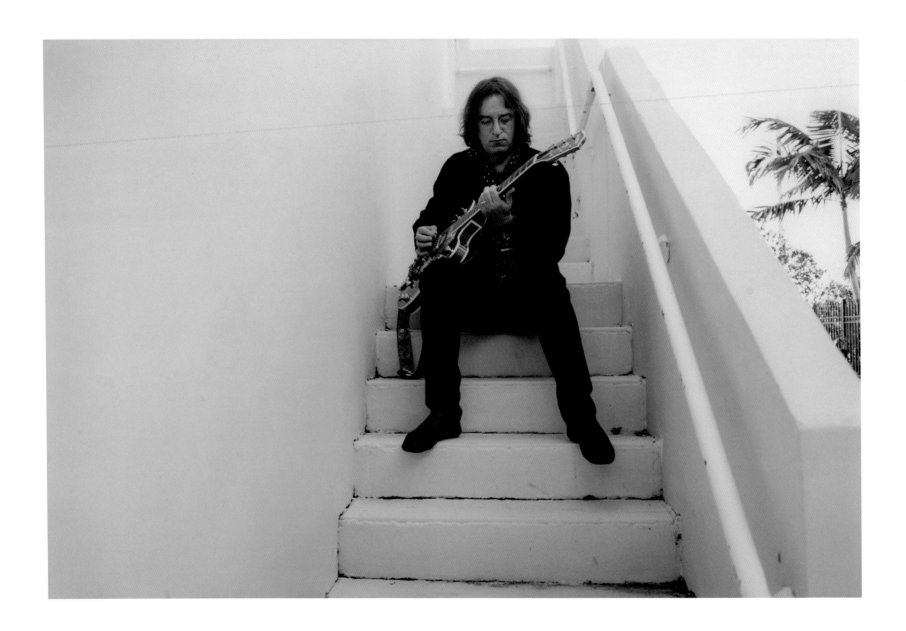

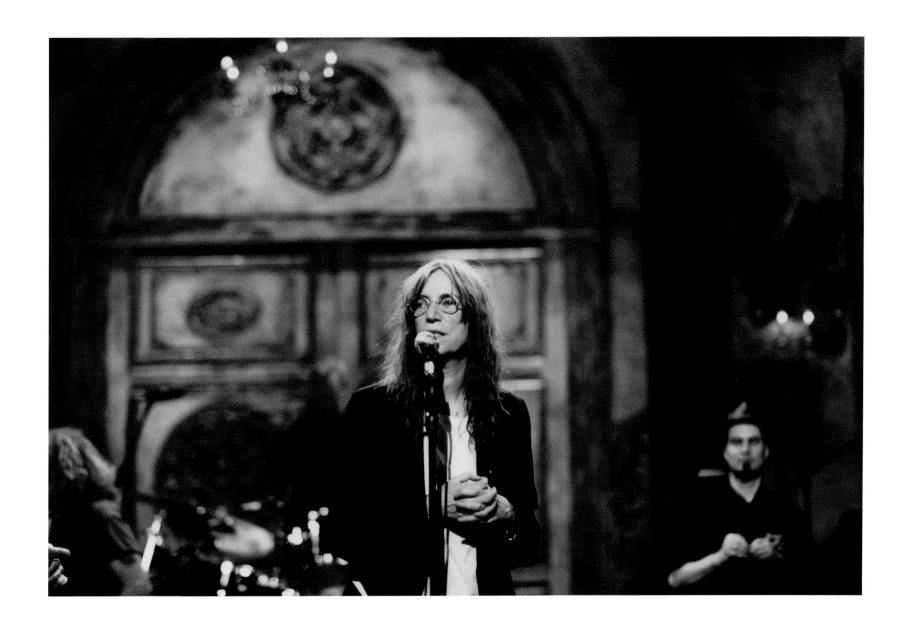

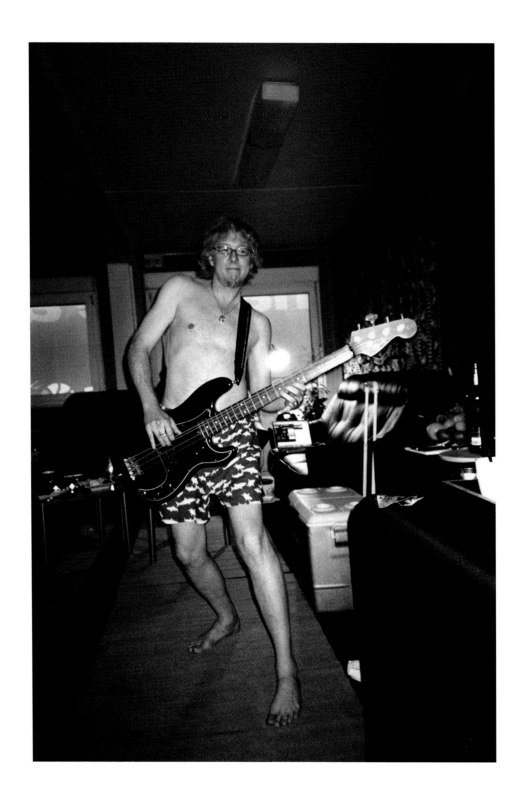

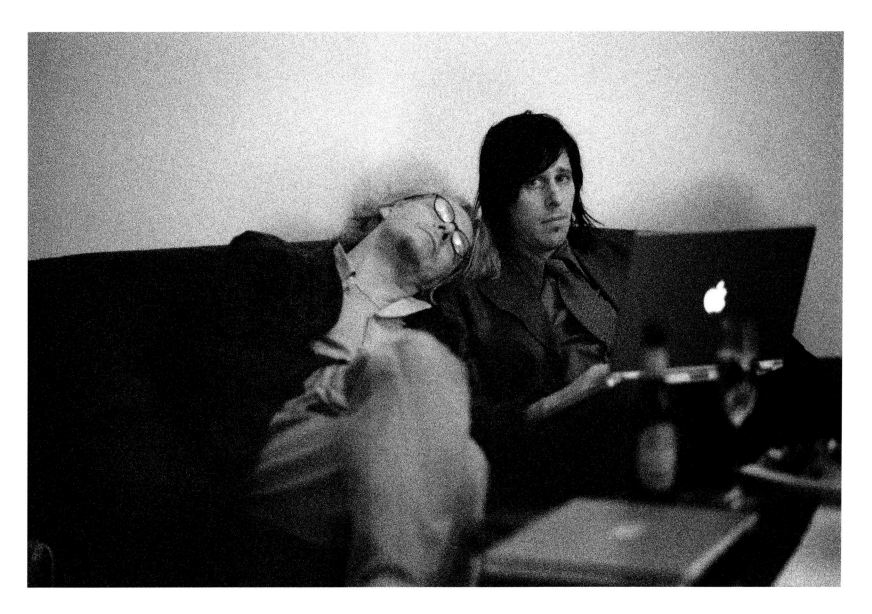

Leaning on Ken - again

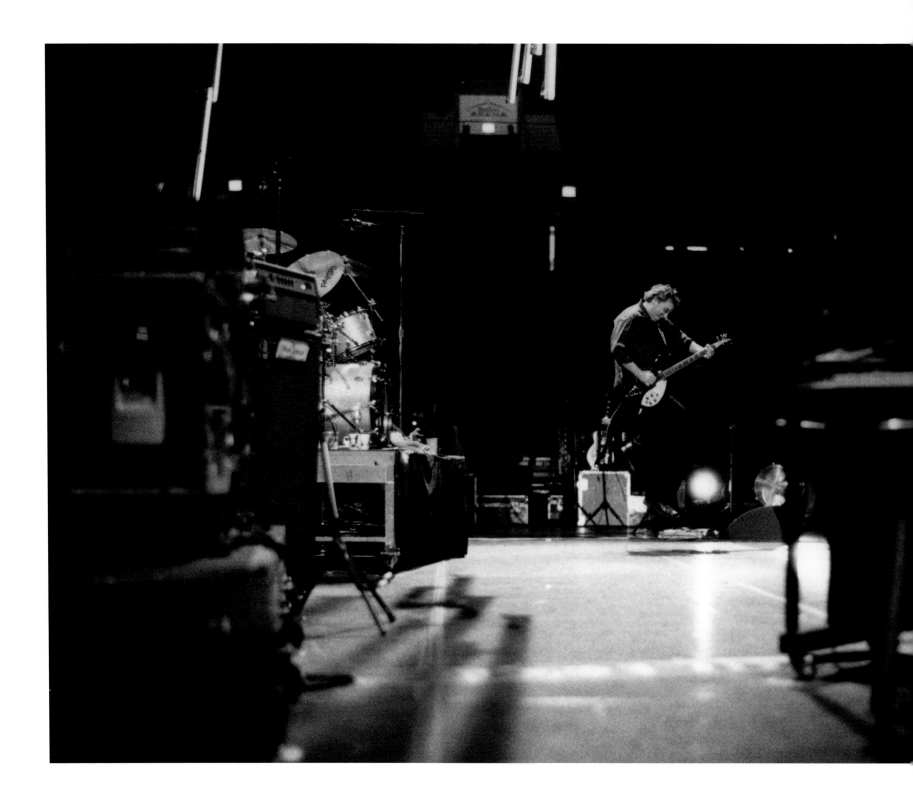

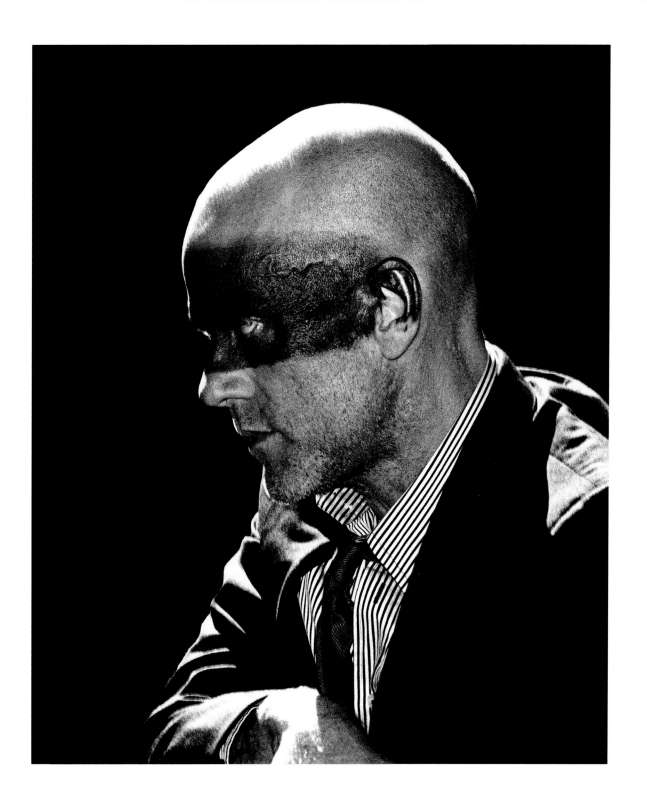

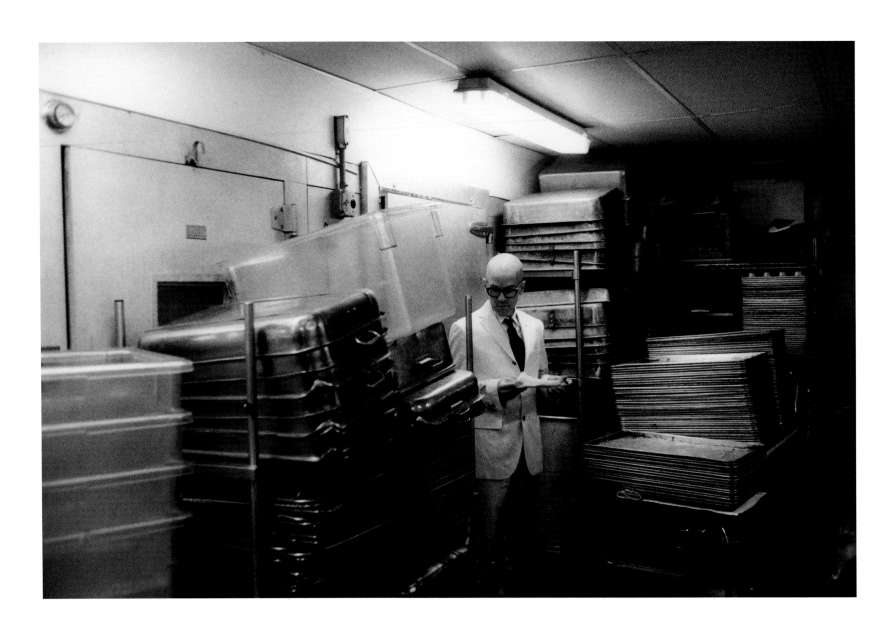

NYc

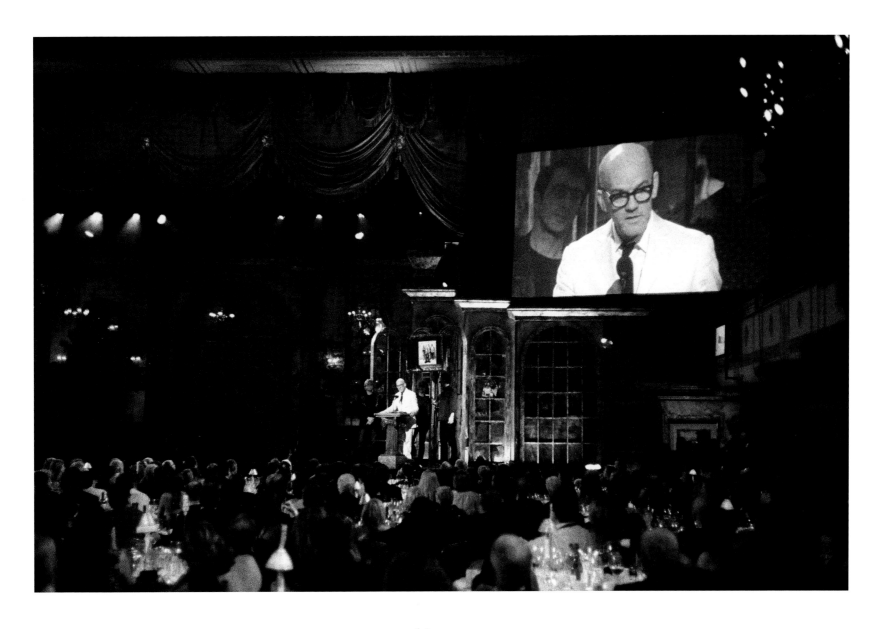

HALL OF FAME

WALDORF ASTORIA NYC
Rock Y Roll Hall of Fame

TO PREPARE FOR THE EVENT

THEN GAVE US A SUITE.

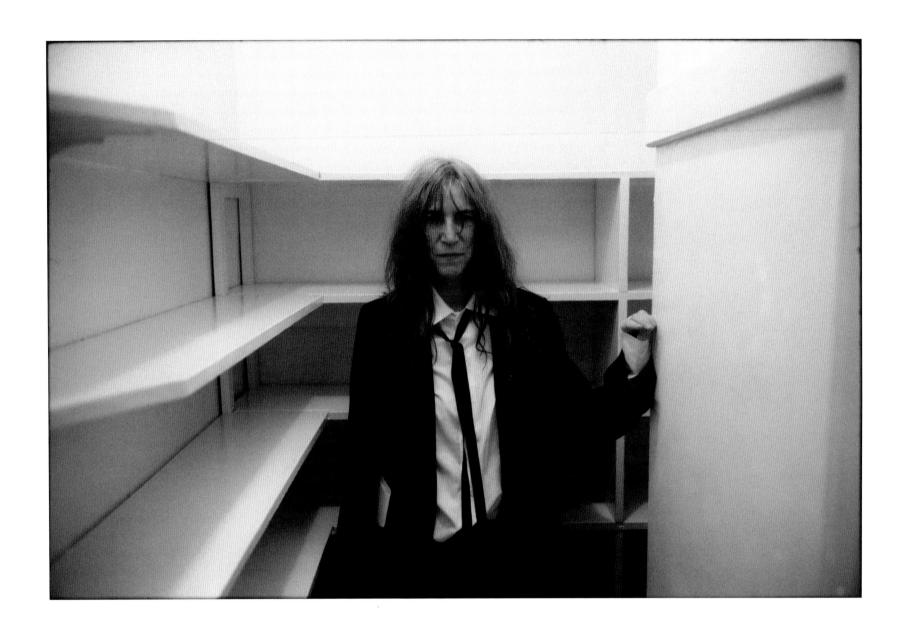

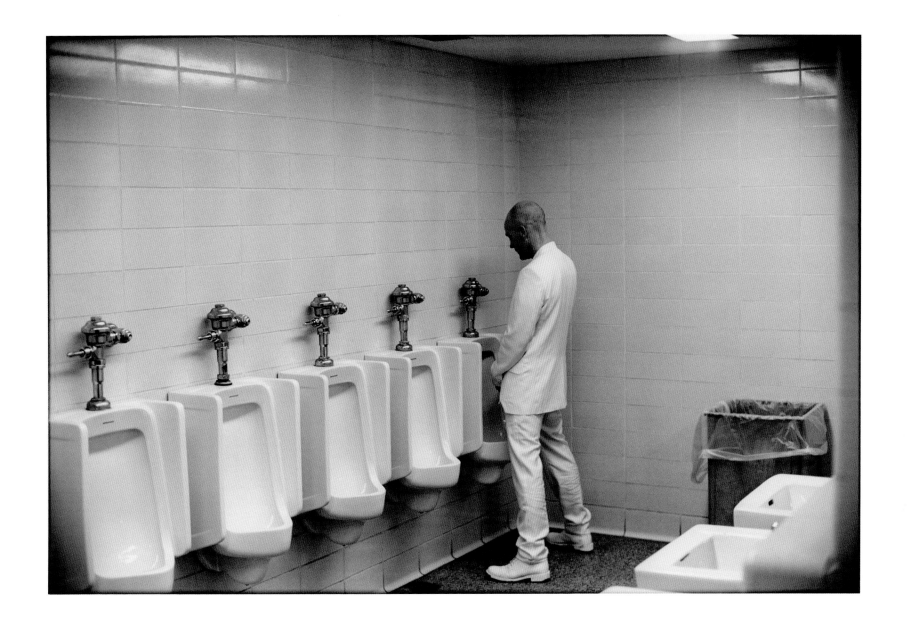

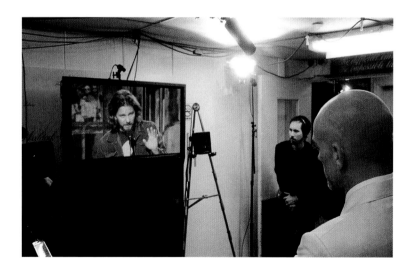

That Eddie just cracks us up

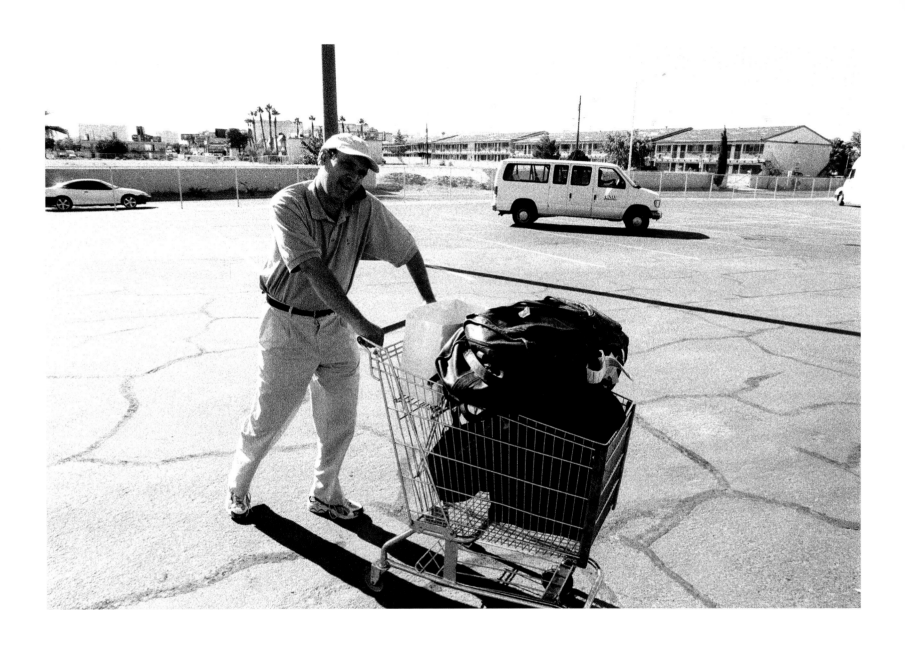

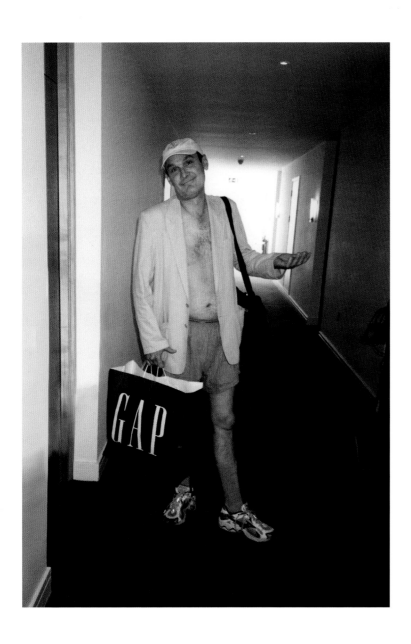

Planes, trains... living the dream!
One of those days when
you just can't remember
anything

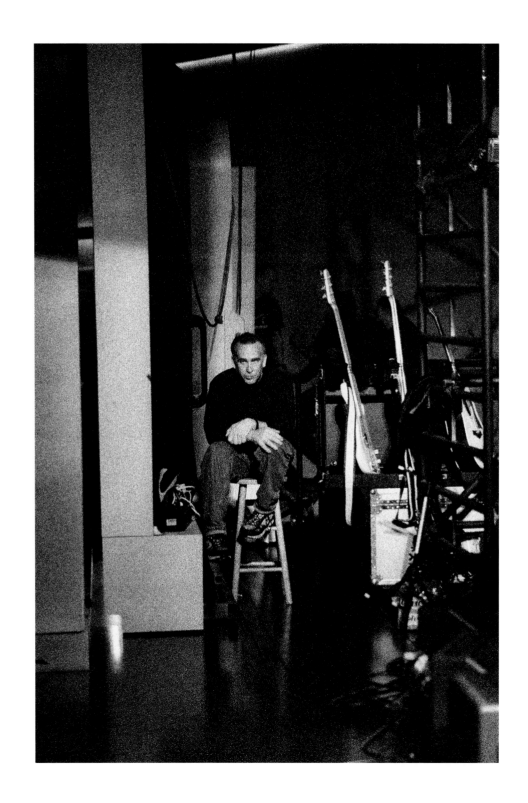

Bob Weber
The man behind De Mann

Dewitt Burton
Down from the mountain

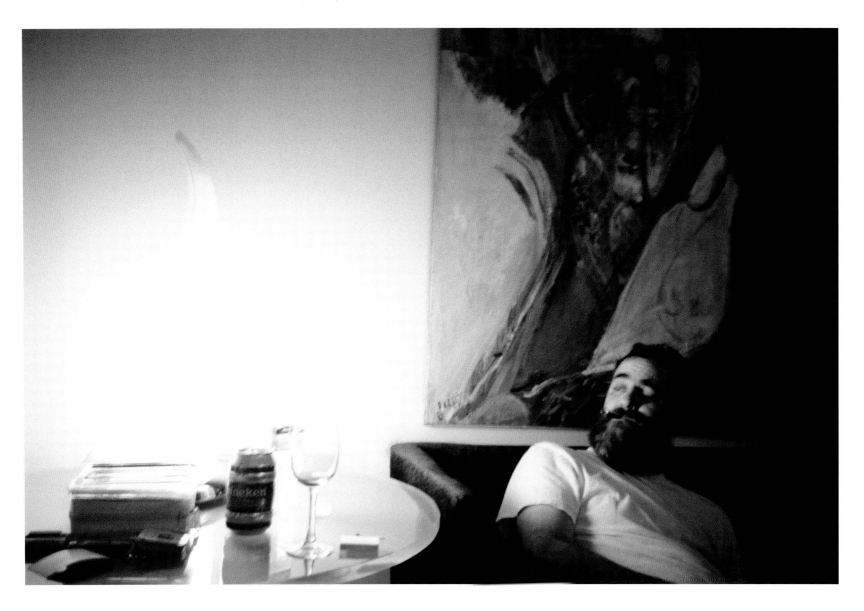

TOUR MANAGER
BLOB WHITTAKER

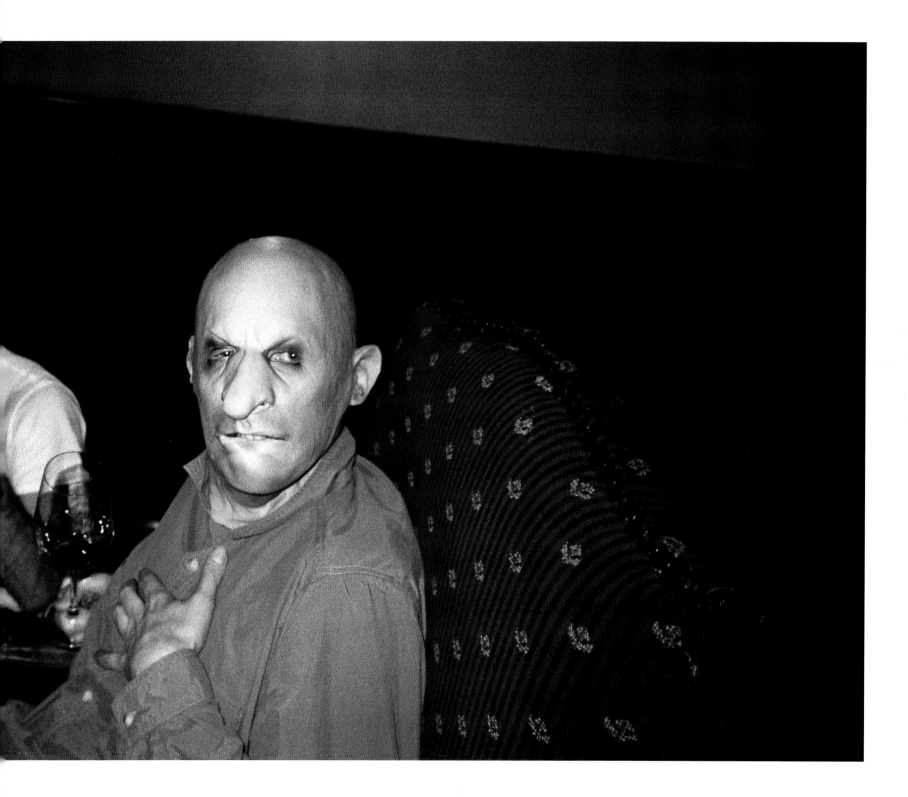

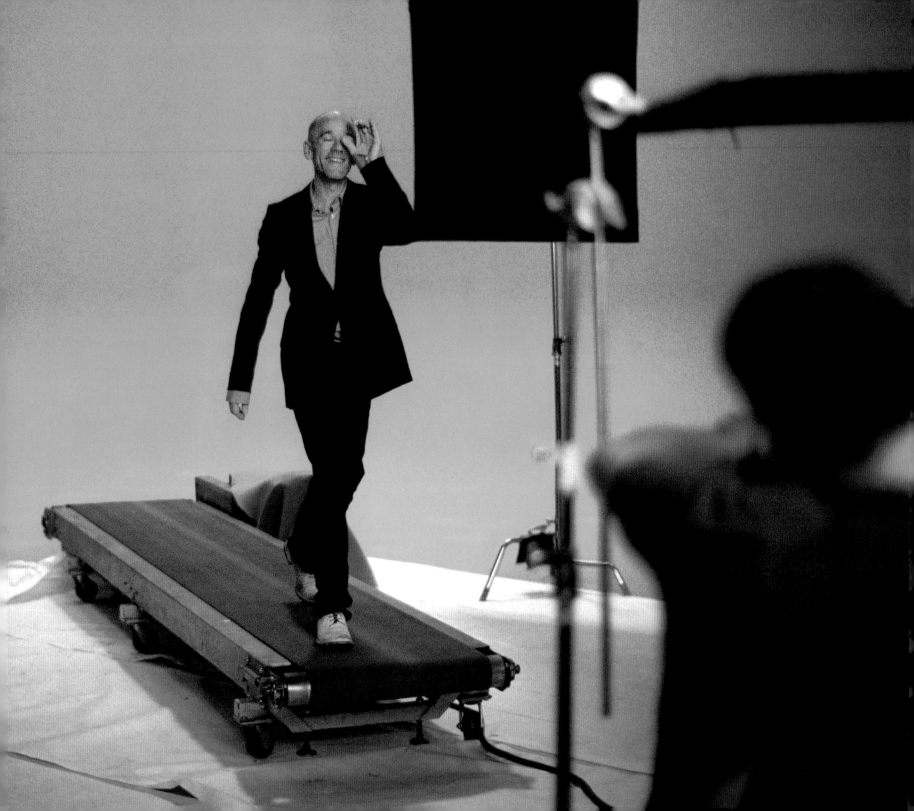

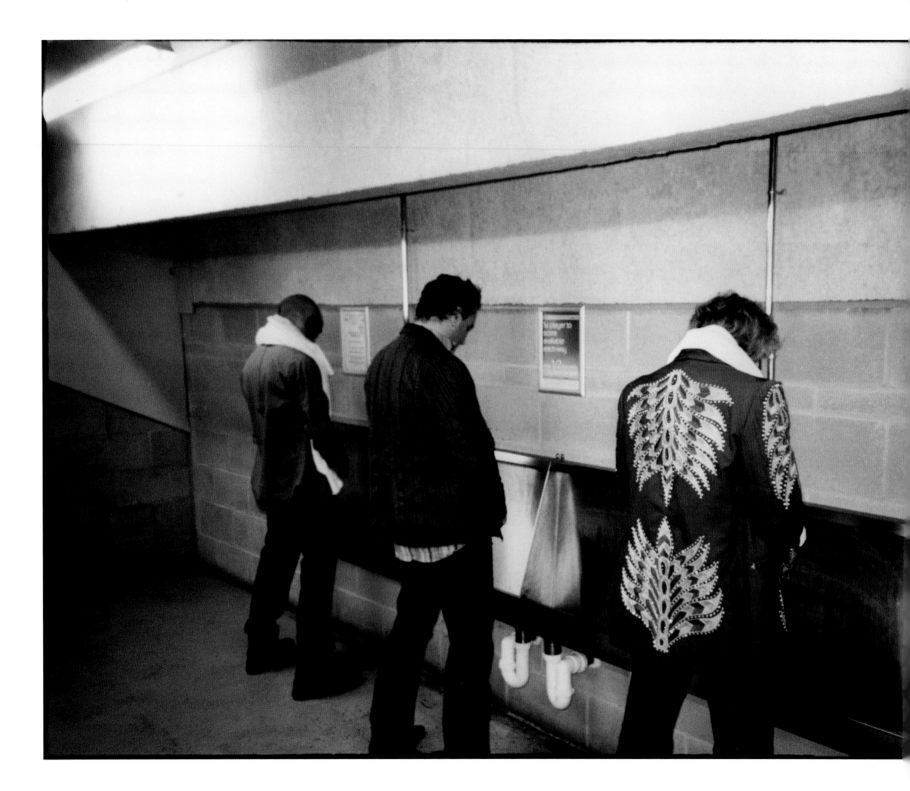

When ya gotta go...

I GREW UP IN WEST SEATTLE

ON 47TH AVENUE SW, the same street that Frances Farmer had lived on decades earlier. As kids, my sister Jana and I had the best early exposure to rock 'n' roll possible. Our teenage neighbor Janeen, five years older than us, was full-on rock, and was never embarrassed or scared to sneak my sister and me out to all-ages shows (thankfully our single mom was a bartender, and we got away with murder). My first concert: The Who's 1982 "farewell" tour, with the Clash opening. I was fifteen, and it was a culture shock in the best formative way (Thanks, Neen!).

I met my friend Bob Whittaker (who would later become R.E.M.'s tour manager) when we were teenagers in West Seattle in the 1980s. We were new wave, though he was more punk. (He would go on to manage Mudhoney before R.E.M.) Hair Mohawked with Knox gelatin and wearing a dumb "anarchy" army jacket, Bob and our other punky friends would come into the restaurant where I worked—Meal Makers—and hardly order anything, eat all the jams packets, drink all the coffee creamers, and almost get me fired (though I managed to hold on to the job for *eight* years). We have been brothers ever since.

By nineteen or twenty I had bought a camera at a garage sale (a Pentax Honeywell Spotmatic, a great camera!), I'd quit art school, and built a home darkroom. I loved being alone in the darkroom with killer music, wine, and cigarettes. Total dreamer. My photos were mostly reminiscent of vintage Hollywood portraits; Technicolor-style on old-fashioned fiber-based portrait paper, with painted oil tint in bright colors. That was the '80s. We'll skip the '90s.

In 2001, Bob introduced me to R.E.M. as a photographer/waiter who could possibly work as an assistant while also providing photography. My first job with the band was

a one-week stint in San Francisco that year to help out with R.E.M.'s performance at Neil and Pegi Young's annual Bridge School benefit concert, which also included Ben Harper, Billy Idol, Pearl Jam, and Tracy Chapman. The evening before the concert, Neil and Pegi hosted a beautiful dinner for the musicians and the crew at their home. It was surreal, yet a comfortable setting. I was shy around Neil, but as I walked by and smiled, he winked, which reminded me so much of my dad. It was the perfect hello.

My first week with the band was crazy, packed with live performances, radio and TV promos, travel back to Seattle for a secret show at the Crocodile Café, and a one-day recording session at Bad Animals where they knocked out a song for a movie soundtrack. I didn't really have time to be nervous. R.E.M. work hard (*whew*), but we managed to hang out and blow off steam at night after these jam-packed days.

A year later, R.E.M. were gearing up for back-to-back tours supporting a "best of" collection and their new album at the time, and I traveled with the band on the tours as Michael's assistant, and have been since. Being Michael's assistant is not about getting the guy caviar and special herb juices or chasing other ding-dong requests. It is about getting all the schedules lined up for what everyone else wants and needs to happen, and just kind of bouncing off each other: it's about finding the funniest YouTube videos,

and bringing all the episodes of *Strangers with Candy* for the tour bus, and, like any other job, it's important to have fun and be fun. Keeping a positive vibe is essential, and sometimes I think I'm better at that than anything else.

Spending so much time with the guys over the years—during video shoots, recordings, rehearsals, on tour buses and teensy planes, live shows, promo tours, at great clubs and bad discos, on their Vote for Change tour and at their induction into the Rock and Roll Hall of Fame in 2007—I know how lucky I have been in getting to be there with my camera, to have earned their trust in me. I carry my Leica M7 camera with me, loaded with whatever film happens to be in it (I still shoot film.) The Leica is the perfect shy and quiet camera because it takes the most beautiful shots in available light, which is the way I prefer taking pictures on tour. Most of the photographs in this book are from prints I made in the darkroom myself.

Writing about how I feel about the guys is difficult. I can't find the right words, so I hope that the photographs will do a better job at that for me. They have my love, and my respect, and those two things are what make up a beautiful friendship.

xo

DAVID BELISLE

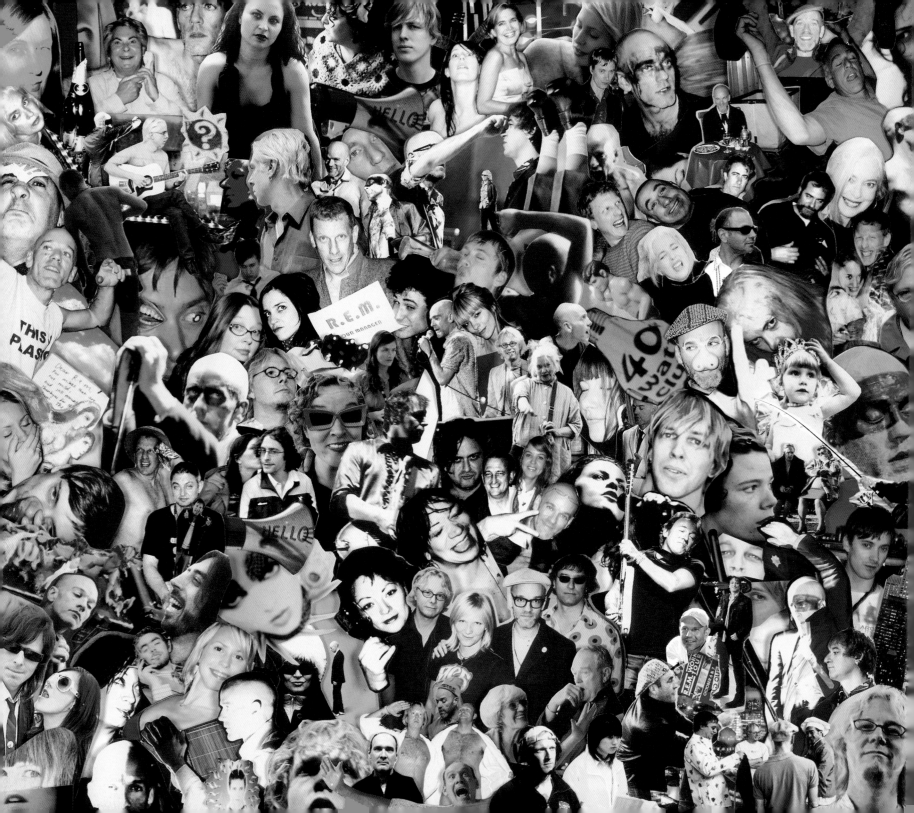

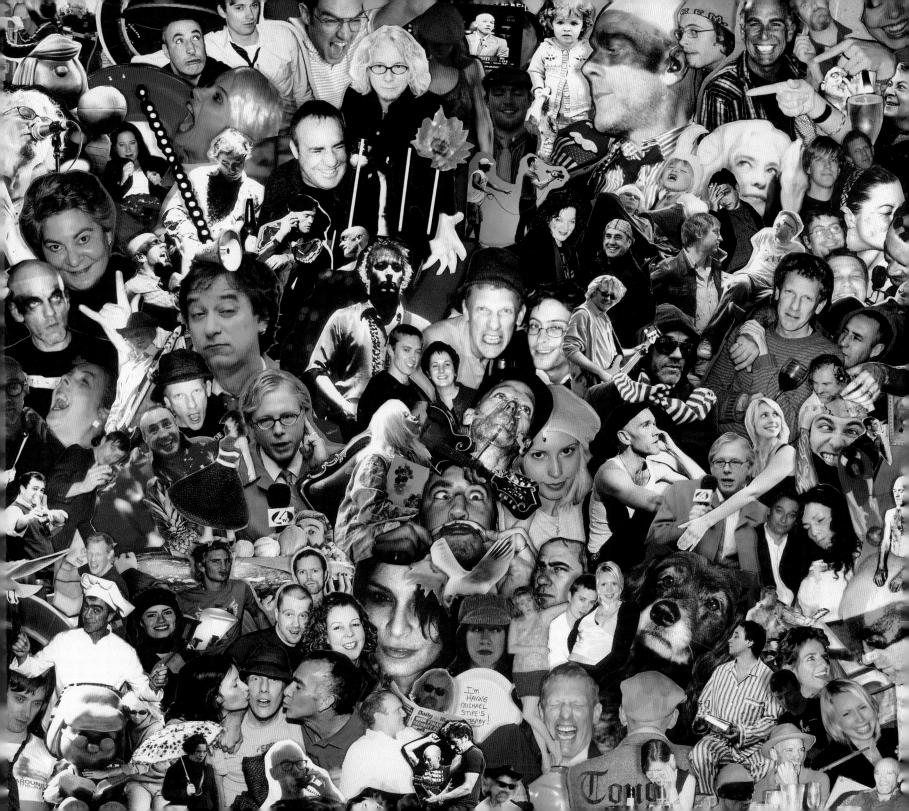

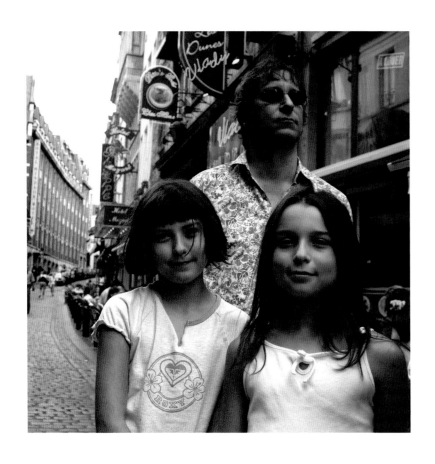
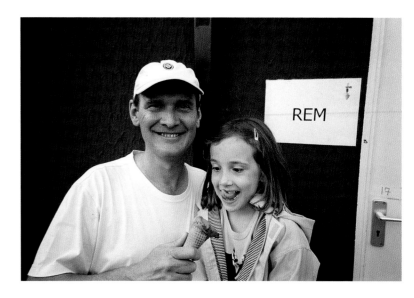
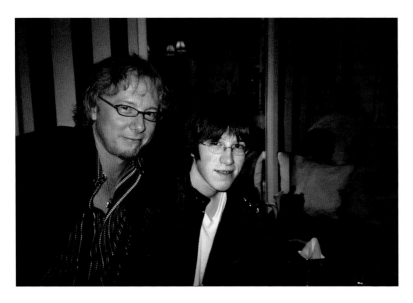
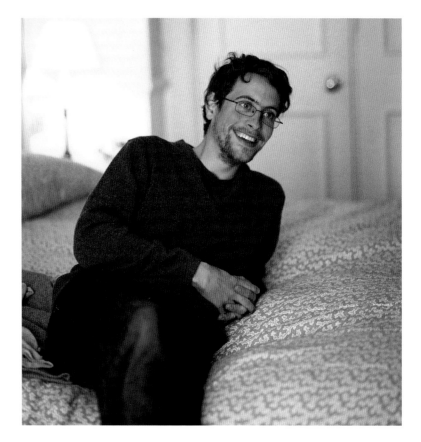

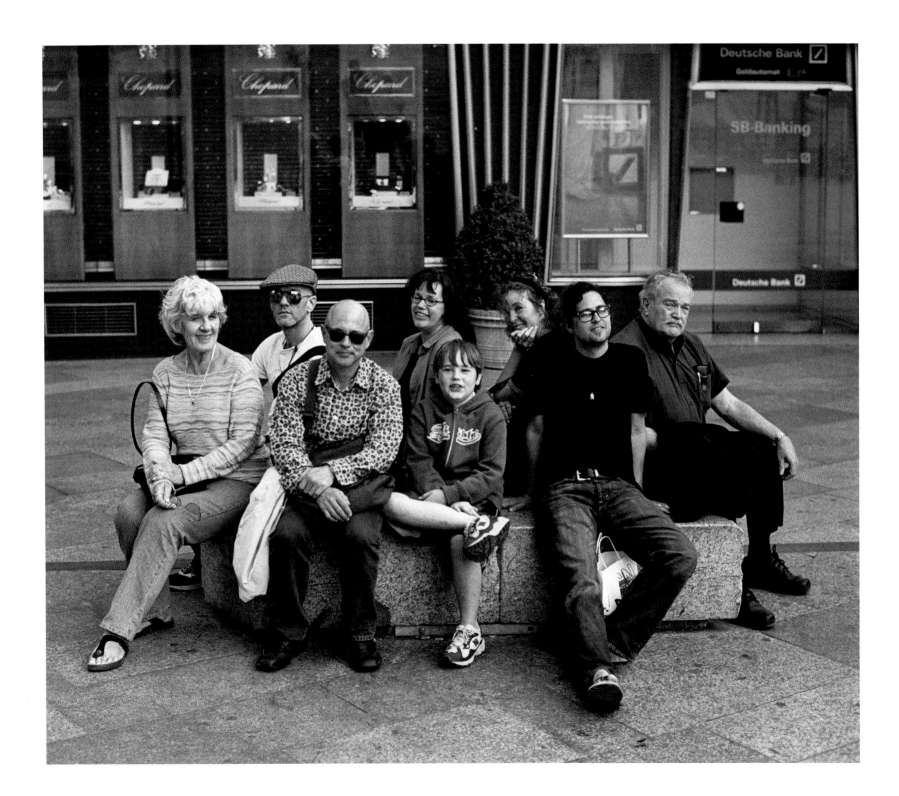

THANKS TO

Kim Buchanan, who hand-constructed the collages (from over 500 snapshots that I cut out with scissors) & who helped me sequence the photographs. I can't thank you enough. I know, I owe you hours & hours in your garden . . .

Corianton Hale, for book design & inspiring calmness.

Michael Stipe, Bertis Downs, Mike Mills, Peter & Zoe & Zelda Buck.

Steve Mockus, Doug Ogan, Lisa Ann Logan, April Whitney, Jacob Gardner & Erin Thacker at Chronicle Books.

Kelly O, Vinny, Annie Marie Musselman, Michael Doyle, Jana Belisle, Sage & Selma (my amazing nieces), Mama, Bob Whittaker, Thomas Dozol (who cuts it, baby), Polly Gregory, Sue Bodine, Anthony Arnove, everyone at the R.E.M. office, Photographic Center Northwest for awesome color darkroom rentals, Gary & Kim at IO Color in Seattle.

R.E.M. friends, family & touring crew. Thank you.

—D.B.

WHO WROTE THE CAPTIONS?
Michael: pages 8, 25, 26, 38, 41, 44, 46, 52, 55, 56, 57, 62, 66, 67, 70, 75, 95, 96, 97, 99, 102, 103, 104, 106, 108, 109, 110, 112, 113, 124, 128, 129, 138, 142, 143, 154, 155, 168, 169, 170, 171, 180
Peter: pages 28, 29, 71, 137, 146, 152, 157, 158, 179
Mike: pages 23, 36, 42, 43, 80, 81, 144, 145, 147, 148, 153, 165, 175, 178, 185
Bertis: pages 78, 177
Zoe and Zelda (Peter's daughters): page 51

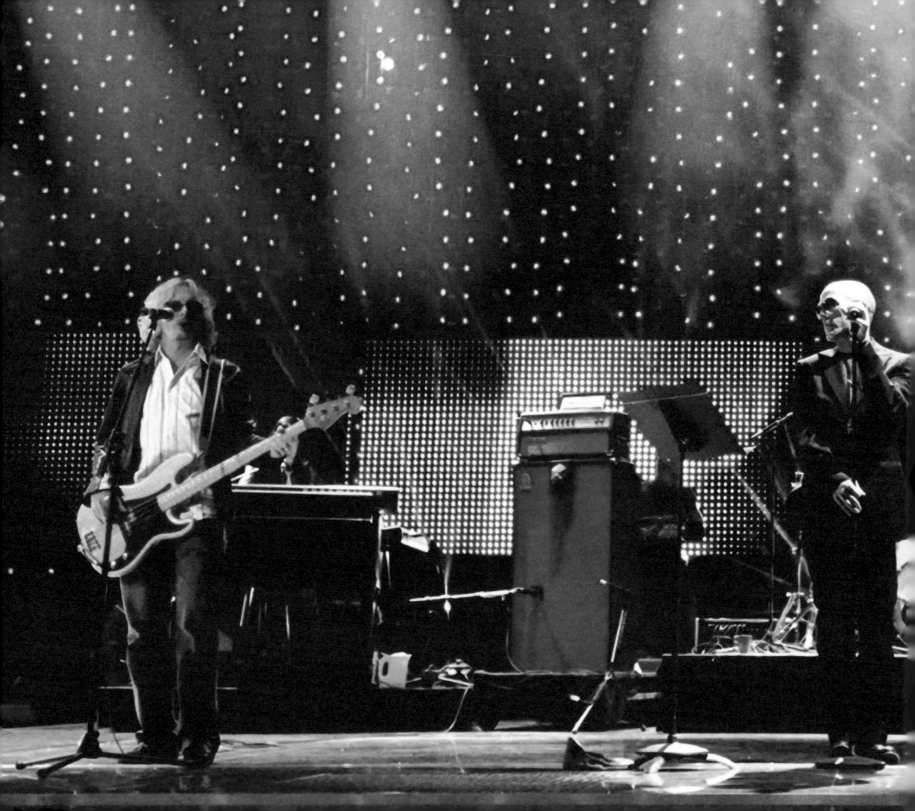